3/01

8

PASTEUPS & MECHANICALS

PASTEUPS & MECHANICALS

A STEP-BY-STEP GUIDE TO PREPARING ART FOR REPRODUCTION

by Jerry Demoney and Susan E. Meyer
Photographs by Jerry Demoney

WATSON-GUPTILL PUBLICATIONS/NEW YORK

Copyright © 1982 by Jerry Demoney and Susan E. Meyer

First published 1982 in New York by Watson-Guptill Publications,
a division of Billboard Publications, Inc.,
1515 Broadway, New York, N.Y. 10036

Library of Congress Cataloging in Publication Data
Demoney, Jerry.
 Pasteups & mechanicals.
 Bibliography: p.
 Includes index.
 1. Printing, Practical—Paste-up techniques.
2. Printing, Practical—Layout. I. Meyer, Susan E.
II. Title. III. Title: Pasteups and mechanicals.
Z253.5.D45 686.2'24 81-21967
ISBN 0-8230-3924-2 AACR2

Manufactured in U.S.A.

7 8 9/90 89

CONTENTS

ACKNOWLEDGMENTS

From the outset it was our intention to create the most definitive book on preparing art for reproduction. Such a goal could not have been accomplished without the cooperation of several professionals who freely offered their skills and facilities to us. Their participation has made it possible to illustrate the book with demonstrations of the very best examples of studio procedures and production alternatives.

The Boston and New York branches of CHARRETTE provided all the materials and equipment seen in the studio photographs throughout the book.

SID MINSON of Royal Composing Room, Inc., in New York, set and reset and reset again the type used for the demonstrations shown in the photographs.

JOHN SCHAEDLER at Schaedler Pinwheel in New York provided the excellent samples of line and halftone variations in Chapter 4 on Art and Reproduction.

KERNER PRINTING in New York opened their facilities to us for Chapter 1 so that we could illustrate the production stages from mechanical to printed piece.

Other individuals lent their professional expertise to this project and, in so doing, helped to make the book itself a model of art skillfully prepared for reproduction. CHARLES SANTOPADRE performed the task of retouching the photograph for the jacket, and TOM RUIS was indispensable throughout the entire project, from his help in organizing the material at the beginning to his assistance with the mechanicals at the end.

And last, but by no means least, DANIELLE DEMONEY without whose "golden" hands and extraordinary patience the demonstration photographs could not have been done.

To all these firms and individuals we extend our most sincere thanks. If the book has succeeded in its original goal, it is undoubtedly to their credit as well.

INTRODUCTION

We decided to write this book because we wish one like it had existed when we were learning how to prepare art for reproduction. Other books devote most of their pages to the reproduction phase—long technical discussions about production—rather than to the preparation stage. We have done the reverse. In order to devote as much space as possible to studio procedures, we have worked with the most commonly encountered method of printing—photo-offset—which explains why no reference is made to gravure or letterpress. The stages of preparing a mechanical for the printer are pretty much the same anyway, regardless of how the type is set or how the piece is reproduced in the end.

We set out to create a book that would assume no prior studio experience, and one that might take the professional a step further in developing studio skills. We wrote the book for anyone seeking basic pasteup techniques: for students, for designers, for in-plant personnel, for publication production departments, and for printers offering layout and pasteup services to clients.

This book is intended to be an introduction to layouts and how to assemble art and type for the printer's camera. There are already several excellent books in related fields that provide extensive information on production, typography, and design (in fact, we recommend them in a Selected Bibliography at the end of the book), but here we will not attempt to go into any greater detail on these subjects than what is essential to the preparation of art for reproduction.

There are three basic ingredients that enter into almost every mechanical:

1. Original line work, for which we provide instruction on basic inking techniques.

2. Art, which includes line and continuous tone and requires knowledge about its handling and reproduction.

3. Type, which has its own set of rules and regulations and necessitates special attention.

These three ingredients are dealt with separately in the book and then brought together when the entire mechanical is created.

Studio terminology does not always represent the most precise use of the English language. What one studio refers to as a "dummy," for example, may differ from that of another studio. Likewise, terms such as "keyline," "copy," and "flat tone" may vary in usage from one studio to the next. For the purposes of this book, we have chosen to use certain terms within a consistent context and we hope they generally apply. It is advisable, however, to agree upon definitions with each new situation in order to avoid unnecessary confusion. The procedures themselves will not vary, of course, but the words used to describe them may.

1: FROM CONCEPT TO PRINT

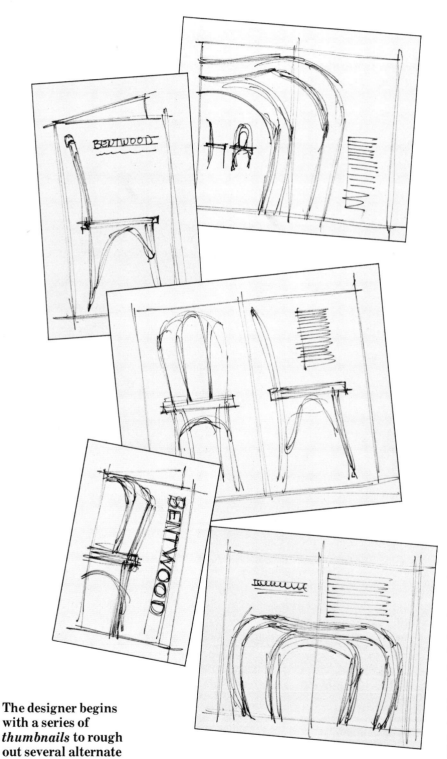

The designer begins with a series of *thumbnails* to rough out several alternate design concepts.

There are several stages through which your project will pass as it moves from the designer's idea to the printed piece. Whether you happen to be the designer or whether you are simply executing the designer's concept, you should be familiar with the entire process from beginning to end. While it's not the function of this book to describe in detail how to design or how the designed piece is produced, this chapter will present the general process involved in taking an idea from concept to its ultimate conclusion.

The Layout

At the outset, a client will convey to you what is needed: a four-page, black-and-white promotional brochure, let's say. The client will hand you the copy or manuscript that must be set in type and several photographs that must be integrated in some logical fashion with the type. You study the material and make some quick sketches until you arrive at two or three possible ways of handling the assignment. To convey your thoughts to the client, you may create three kinds of layouts as you develop the general idea from one of several concepts to a final, precise indication of how the printed piece will appear. These three stages of presentation are thumbnails, roughs, and comprehensives. Whether you use one or all of these for a job depends on your approach and on your rapport with the client.

Thumbnails: Miniature sketches are the most rudimentary method of developing visual ideas. These can be done in a very informal way be-

cause they are more for you than for anyone else. They are a design shorthand, permitting the greatest latitude and flexibility for considering the overall design elements. Thumbnails are generally made on layout paper, white bond, even on scraps of paper, backs of envelopes, and napkins!

Roughs: These are like enlarged thumbnails — generally made on layout paper to the actual size of the finished piece. Roughs can be pencil layouts, or color may be indicated with markers. They may be a guide for you, or you may even show them to the client, depending on your working arrangement.

Comprehensives: This is the most finished layout, normally used for presentation to the client and to ensure it meets your design objectives. The *comp*, as it is called, simulates the printed job as closely as possible.

Creating an attractive comp is a skill unto itself and may make the difference between whether a client favors the design or not. Comps are prepared in all media — in markers or paint — and varied presentation techniques are very important skills to develop. After all, the client is not, in all probability, a visual person. He or she may be a marketing manager or an editor, perhaps, whose area of expertise is not in being able to *interpret* a design idea. It's your job to make the design of the entire piece absolutely clear before any funds are invested in its production.

If more than one page is being presented to the client, the designer shows a dummy of the entire piece to indicate how each page relates to the next and how it folds, if this is a consideration. The comp provides the basis for specifying type size and measure, sizing photographs and/or line art, as well as indicating their placement within the design. The comp is the final layout to be used when preparing the mechanicals.

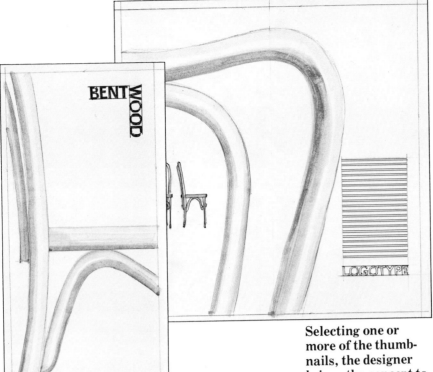

Selecting one or more of the thumbnails, the designer brings the concept to a more developed state called a *rough*.

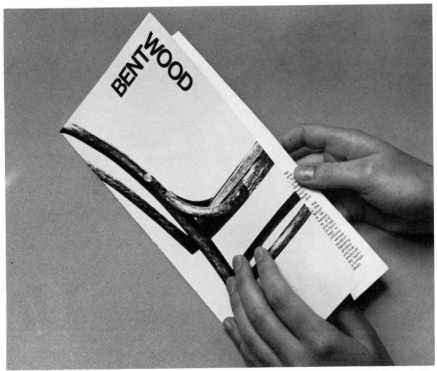

A polished idea of the concept is presented in a *comprehensive*, in which the designer simulates the final reproduction.

The Type

The designer is given the manu-script — or *copy* as it is called — and specifies the typeface, the size, style, and weight to be used for the design. Selecting type is both an esthetic and a technical choice, because the selection must be attractive but must also fit within the layout. This can be calculated by counting the characters in the manuscript and translating this figure into the amount of space consumed when the copy is set in type. (This process, called *copyfitting*, is described in detail in Chapter 6.)

Once the type has been selected and the layout approved, the manuscript is released for type-setting, and in a short while the first type proofs are returned to the studio. If the copy appears as planned — free of errors that affect the appearance and size of the type — the proof is laid in place on the layout to create what is called a *dummy*. At this point, the pictures are laid out as well. The art is scaled — marked for the correct en-largement or reduction and sent out for photostats. The photostats will be used with the type proofs in the design for size and positioning.

After all the typographic ele-ments have been checked for accu-racy, they are returned to the type-setter for corrections.

The Mechanical

The final stage — and this is the stage about which our book is most con-cerned — is the *mechanical* or *camera-ready copy*, that is, layout pages for the printer to process. At this stage all the copy and art are pasted into position. Any imperfec-tions will appear — unless correct-ed — in the printed piece. The align-ment of elements must be precise; the type clean and free of blemishes; rules precisely drawn, free of any dirt specks or ink blotches.

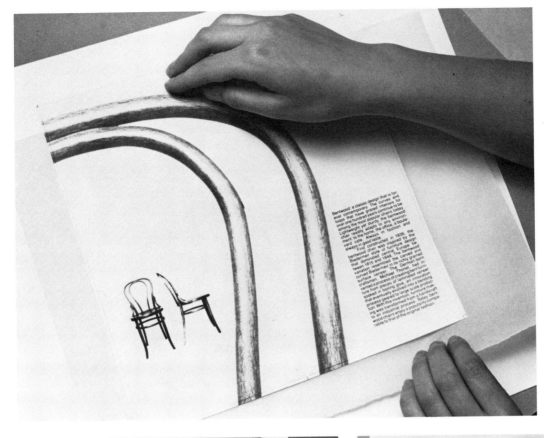

The type proofs and photostats are assembled to create a *dummy*. All corrections and changes are made at this stage.

After receiving final type proofs (*repros*), the studio creates a *mechanical* in which all elements are cemented into their precise position. The mechanical provides *camera-ready copy* that can be photographed by the printer and can be used as a guide to the printer for the placement of all elements in the final reproduction of the piece.

In the camera room, a large bellows-type camera is used to photograph the type as it appears on the mechanical and the art according to the marked instructions.

From Mechanical to Film

The printer takes the mechanical and sends it first to the camera room where the elements of the mechanical are photographed by a so-called *process camera*. Although the camera used is one specifically designed to photograph material for printing, the principle is still the same as that involving any simple camera: light entering the lens of the camera creates an image on a negative, and this negative is used to make a positive print. The process camera distinguishes between shooting line copy and shooting tonal or halftone copy, but the final negative used for making printing plates combines both elements into a single piece of film.

Line copy — including type and line art — is photographed directly from the mechanical you provide. Continuous tone art is photographed individually, to the sizes you indicated, directly from the original photographs or art you provided along with the mechanicals. These are photographed through a screen that breaks up the tones into dots. These dots translate into areas that

provide the full range of gray values, from black to white, depending on the number, size, and density of the dots in any given area.

Likewise, color is photographed through four different screens, each screen angled a slightly different way, which — with each piece of film designated a color of red, yellow, blue, or black, and then placed one over the other — will simulate full color. The principle applied is not unlike the dots painted by the pointillist artists in the 19th century. (More about art and reproduction is described in Chapter 4.)

The printer takes the individual pieces of film — the halftone and the line film — from the camera room to the stripping room. The elements are then combined according to the mechanical you provided. Using a razor-edged blade, the stripper cuts apart the individual elements and inserts them into "windows" he has cut into large opaque plastic sheets, generally referred to as *goldenrod paper*.

This film — with all the elements stripped in place — is processed very crudely for a photographic print called a *blue* or a *brown print*, depending on the specific chemical process used. This proof will be sent to you for checking. Are the elements stripped into position correctly? Has the artwork been properly photographed? Are the pieces perfectly aligned? Is the sequence right? Is there dirt on the film? These are the kinds of things anyone in an art studio must consider when checking a page proof.

From this brief description of the printer's camera and stripping operations, you can see that the mechanical provides two critical functions:

1. The mechanical itself contains actual art that is photographed — type and line copy that is registered by the printer's lens.

2. The mechanical shows the precise relationship of the elements within the piece so that the stripping department can assemble these elements in their correct positions.

That is why the mechanical must be clean and precise. Any sloppiness or inaccuracies made in preparing art for reproduction will affect the work of the printer at the other end.

From Film to Printed Piece

After the proof has been approved, the printer makes the corrections and takes the final film to the plate-maker's room. Now the image on the film is etched chemically onto a plate, using a process not totally unlike the process of printing film on photographic paper.

The printing plate is washed off thoroughly and brought into the press room where it is mounted onto a printing press for which the plate has been prepared. The plate is inked, and sheets or rolls of paper run through the press are stamped by the surface of the inked plate or by a rubber roller that receives the ink from the plate. (The latter process is called *offset*, simply because the rubber roller is an offset impression from the original plate.)

It should be apparent by now that any artist involved with printing should be familiar with the technology of typesetting, printing, and binding. Technical factors influence good design and the way in which type and art are prepared for reproduction. If you're not already acquainted with these aspects of the design process, we urge you to consult books specifically devoted to type and production (see the Selected Bibliography in the back of the book) and to visit compositors and printers to see for yourself. You'll find such an exploration not only useful, but thoroughly fascinating as well.

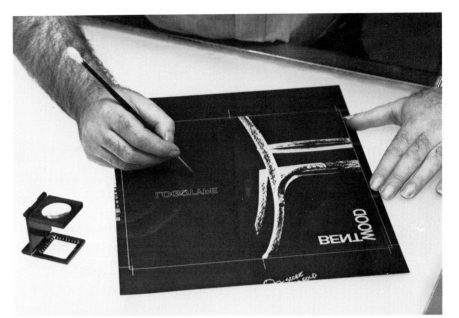

The negatives of the shots taken in the camera room are combined in the stripping room. The art photographed as halftone is combined with the type to form a single negative.

The negative is made into a plate and the plate is placed on a press. The plate is inked and sheets or rolls of paper run through the press to be stamped by the plate.

If the mechanical has been prepared correctly, the final piece will come off press precisely as anticipated.

2: MATERIALS AND TOOLS

There is truth to the adage that a worker is only as good as the tools used for the job. Preparing mechanicals demands such precision that high-quality tools designed to perform the correct functions are standard equipment required for the studio artist. Here are the furniture, instruments, drawing and cutting tools, and the miscellaneous materials you are likely to use in the course of your work.

Drawing Table

All drawing tables (or *drafting tables*, as they are also called) have two features in common—the angle and the height of the top are adjustable. Drawing tables come in a variety of forms: some fold for easy storage, some have cast-iron bases, some are four-legged. When selecting a table, be sure it's sturdy and has an ample working surface of 23″ × 31″ or 31″ × 42″.

The drawing table should also have a so-called *true edge*—a metal edge perpendicular to the bottom edge of the table—built in or clamped on the left-hand side to serve as a guide for the t-square. Most tables also contain a wooden edge, a lip at the base of the top surface, to prevent tools from sliding down when the table is at an angle.

The properly outfitted studio contains an adjustable drawing table, a well-illuminated drawing surface, a taboret for holding tools and equipment, and a swivel chair whose height and back tension are adjustable.

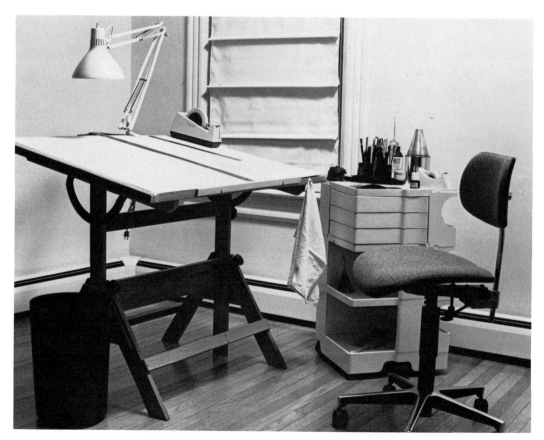

Because you'll do extensive cutting with a razor blade, it's advisable to protect the table's surface with a piece of illustration board or a specially designed vinyl cutting surface with a self-sealing feature. Attach this covering to the drawing table with tape or thumbtacks so that you can replace it periodically.

Taboret

Easy access to your tools makes any job a great deal easier. Place a taboret, which is a small cabinet, at the right side (or left, depending on which hand you work with) of the drawing table. The surface should be large enough to hold the tools you use during the job, and there should also be a sufficient number of drawers and compartments for storage.

Lighting

Avoid working in an area that has insufficient lighting or glaring light. Eye strain and distracting shadows can diminish your capacity for detail work, and will fatigue you very rapidly. If your workroom is poorly lit, attach a lighting fixture to the top edge of the drawing table. Select a desk lamp for this purpose that has a long, easily adjusted arm for positioning. Use a lamp that is fluorescent, incandescent, or a combination of both — as long as the quality of light is sympathetic to your purpose. A so-called *color-corrected* light is most accurate for your color work.

Light Box

A light box is a handy addition to your studio. By placing transparencies and slides on the illuminated surface, you can more easily study art for color and layout. Some kinds of pasteup work are also done better on a light box, as you'll see later.

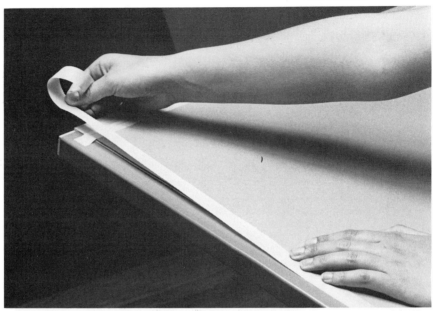

Tape a sheet of illustration board to the drawing table to protect the surface from cut marks.

A light box is used for examining transparent art and for some types of pasteup work.

Measuring tools include a steel t-square, a steel ruler, a type gauge, and a scaling wheel.

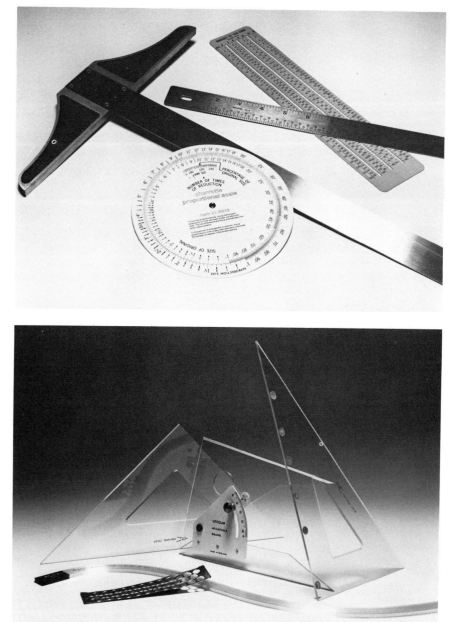

Plastic triangles are available in different sizes and angles. An adjustable triangle can also be used. Use a flexible curve ruler as a guide for unusual shapes. Also handy are *lifts*, punched out of metal sheets and adhered under straightedges to prevent ink smudging.

T-Square

The t-square—used as an edge for cutting, ruling, and squaring—is just about your most valuable tool. Durable and accurate, a steel t-square will not be damaged if you cut against it. Select a high-quality t-square whose head is firmly fixed to the straightedge, and avoid the plastic models because they are less accurate and easily damaged by razor cuts. A t-square with a beveled edge is particularly useful for ruling because the edge will not grab the ink, causing the line to spread. T-squares come in a variety of lengths, but the 20″ or 24″ will probably be the most practical for your purposes.

Ruler

Purchase a steel ruler—rather than plastic—so that it can serve as a cutting edge as well as a measuring instrument. There is an added advantage too: the steel ruler's heavier weight makes it a more stable instrument to use. A ruler 18″ long, graduated in picas, inches, and agates along the four edges, is most practical.

Type Gauge

A type gauge—the Haberule is the most well known—tells you exactly how many lines of type will fit within a given area. On the gauge there are marks indicating the sizes of type and spaces in between the lines. You may find this a serviceable item when specifying type for your layouts.

Proportional Scale

For calculating the sizes and proportions of enlarged or reduced artwork, you'll need a device called a *proportional scaling wheel*. This is a flat, lightweight plastic dial that, when adjusted, shows you the correct dimension of the art without computation.

Triangle

For drawing vertical lines, the triangle is placed as a guide along the edge of the horizontal t-square. Made in transparent plastic or metal, triangles come in several sizes, shapes, and colors. Both 45° and 30°-60° triangles are handy and 6″ or 12″ sizes are most convenient. Some artists prefer an 8″ adjustable triangle. Don't use the triangle as a cutting edge unless it is metal. You'll destroy a good triangle with cut marks.

Pencils

For drawing a plan of the pasteup or for thin guidelines, a hard 2H drawing pencil is advisable. The hard lead stays sharp, makes very thin lines, and leaves a light gray mark easily removed with an eraser.

When you mark your pasteup with guidelines or instructions that you don't intend to have reproduced in the printing process, use a nonreproducible blue pencil (or pen). A red pencil will also come in handy for marking guidelines you *do* want to appear on the negative.

A chisel-point pencil is the best to use for creating the illusion of type in presentations to the client. Keep one on hand. If you are unable to locate a ready-made chisel pencil, follow the instructions in Chapter 6 for making one of your own.

Pens and Markers

Keep a supply of fountain pens and ballpoint pens on hand also. Ballpoints in red, blue, and black, felt-tip pens, even a fine-tipped crowquill pen can come in handy for making minor corrections. Lettering pens — with flexible points that are interchangeable and fit into a handle — are useful as well. The sizes and shapes of the nibs vary considerably so that you can readily locate one that suits your specific job.

You can use an assortment of markers to write instructions or to color-key overlays, among many other things. Likewise, a grease pencil (or *litho* pencil as it is also called) is used for marking slick, glossy surfaces, such as photographs and ace-

Keep on hand a variety of brushes, ballpoint pens, pencils, ink and poster paint, a crowquill pen, razor blades, push pins, scissors, tweezers, erasers, and miscellaneous items.

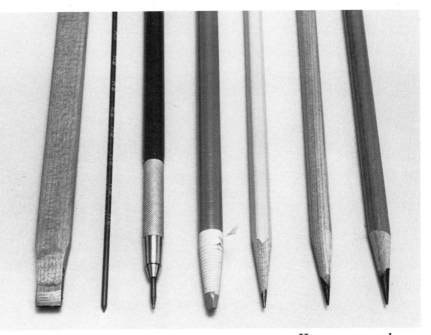

Here are several drawing instruments. From left to right: a chisel-point pencil, a graphite lead and its holder, a grease pencil, a drawing pencil, a nonreproducible blue pencil, and a red pencil.

A set of markers in a variety of colors is useful for preparing layouts and comps.

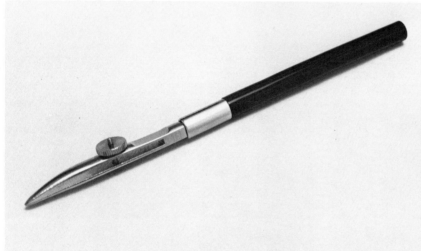

The ruling pen can be adjusted to create lines of varying thicknesses.

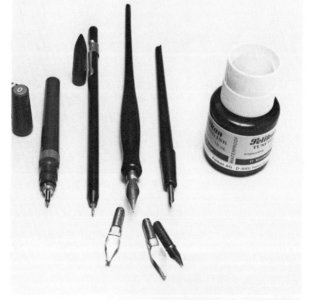

A technical pen is a handy instrument for ruling. Shown from left to right after that are the ballpoint pen, lettering pen and points, crowquill pen, and ink most commonly used for these instruments.

tate. These marks can be removed from shiny surfaces by wiping with a rag or tissue.

Of all the marking tools needed for reproduction, none is more essential than the ruling pen. It is a drafting instrument designed to draw even, consistent lines of varying thicknesses. Be sure to select one that is high quality and keep it clean at all times.

Wash and dry the ruling pen immediately after each use, even if you plan to use it later. Don't permit the ink to dry on the blades of the ruling pen because the inks you are apt to use become waterproof when dry. It's the carbon in the India ink that makes it very difficult to remove after drying. But if you have to remove encrusted ink from the ruling pen, pour a small amount of ammonia into a jar and soak the point for a few moments. Shake the pen and towel-dry. With care and proper use, your ruling pen should last indefinitely.

A technical fountain pen, such as the Rapidograph, is another type of drawing instrument for which you'll probably find much use. A plastic cartridge that holds the ink and several points of different widths that can be inserted into the handle make this type of pen most useful. The ink cartridge is large enough to hold ink for an entire session, eliminating the distraction of refilling during the job. The width of the line can be easily matched from one inking session to the next. The technical pen performs more efficiently if you use it regularly, and it must be maintained properly with periodic cleaning and oiling. Start with a basic kit and add to it as you learn more about what is needed.

Brushes

For whiting out with opaque paint, for retouching lines in ink, and for filling in, a brush may be the preferred tool. A red sable watercolor brush, in a number 3 or 4 size, is most practical. The smaller brushes (from 000) to the larger ones (to 12) may be required for other kinds of work. The red sable brush holds a sharp point, can be loaded with a sufficient quantity of ink or paint, and holds its shape for a long period of time. The size and shape of the marks can be varied by the amount of pressure you apply and by the part of the brush used.

Take good care of your brushes. Mix paints in a china tray designed for that purpose. Wash them thoroughly with soap and lukewarm water after each use and "point them" into shape with the tips of your fingers after the bristles have been washed. It's advisable to use the same brush for the same purpose — keeping the brush for black retouching separate from the brush used for white opaque paint.

Compass

For drawing circles, a compass is the instrument you'll need. One leg of the compass is fitted with a needle point, and the other leg holds a piece of graphite or a ruling pen.

There are several types of compasses — the bow, drop, friction, and beam compasses — with a range of sizes in each category. The most all-purpose instrument is the bow compass. The others are used for larger or smaller circles.

Dividers

Flexible dividers are used to take a measurement of one thing and transfer it to another. The needle-pointed legs are set to a specific width, providing an accurate measurement gauge far more precise than that of measuring with a ruler. Distances are marked by making tiny holes in the surface of the paper with the needle points. Use plain or bow dividers; the latter have a screw adjustment that holds the points securely in the position you've set.

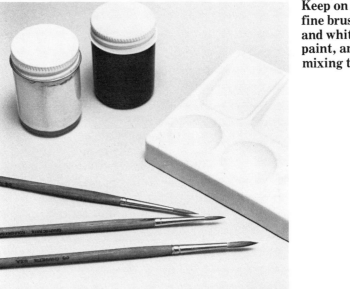

Keep on hand several fine brushes, black and white poster paint, and a china mixing tray.

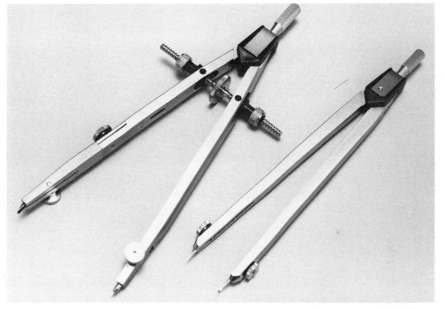

A compass (left) is used for drawing circles, and flexible dividers (right) make it possible to transfer a measurement from one place to another.

Erasers

Use a soft eraser for removing pencil marks. The very soft gum eraser is desirable when there's danger of damaging the surface, but it will deposit crumbs of rubber after it's used. The kneaded eraser is soft and malleable, and can be pressed into any point or shape and will not deposit crumbs. The harder erasers—such as ink or pencil erasers—should be used when rough removal is desired or for more stubborn lines that cannot be eliminated with the softer varieties.

You probably won't find an eraser that is suitable for removing ink lines. In this case it's easiest to eliminate marks by covering them with paint, by scratching them away with a razor blade, or—if the ink happens to be on acetate—by wiping liquid eraser or Windex over the surface with a cotton swab.

Tweezers

Tweezers especially made for studio functions are designed so that you can lift and place pieces of paper accurately. Pointed tweezers are ideal for lifting very small pieces of paper needed for corrections, and they are available in a self-closing variety so that you clamp the paper and release it only when you squeeze the tweezer handles.

Cutting Tools

The single-edged industrial razor blade is the tool most frequently used for cutting paper. These blades are inexpensive, so buy several at once and discard them after they've been used a few times because they dull quickly. (Always cover the razor blade edge with masking tape when discarding or storing in order to avoid accidents.) As already mentioned, cuts are made with the blade held against the metal edge of the t-square or ruler—never against plastic or cardboard.

When you cut heavier paper—illustration board, for example—use a mat knife, rather than the single-edged razor blade. A razor-sharp blade locks into the handle. The blades are interchangeable, and an extra supply can be stored in the hollow handle. Also interchangeable are frisket knives (such as the X-Acto brand) used for delicate cutting of friskets, films, and stencils. There are also swivel knives designed to cut curved lines and circle cutters that attach to a compass.

Erasers are available in a number of densities: from extremely hard to the kneaded eraser that can be molded into shapes with the fingertips.

Cutting tools include mat knife (left), razor blades, and X-Acto knife. After a piece of copy is cut, it is transferred from one place to another with a pair of tweezers (right).

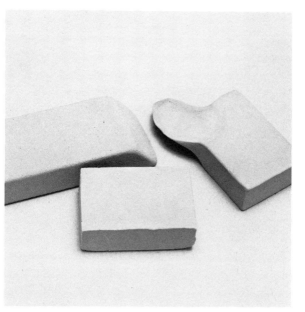

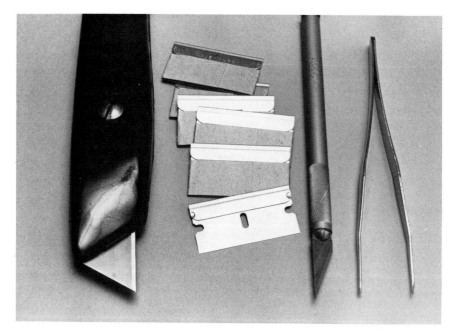

Whites and Blacks

You'll frequently find occasion to make ink marks and to remove them. Drawing inks create a dense, waterproof mark that flows smoothly from a pen or brush, dries rapidly, and adheres to most drawing surfaces. Black ink is fairly standard, but there may be occasions to use red ink as well for creating guidelines.

For covering imperfections, a white poster paint—very opaque—is simply painted over the offending mark. Poster paint is also used for creating white marks on a black surface and can be applied with the ruling pen or compass if it is diluted with water to the consistency of ink. Bear in mind that poster paint will cover ink, but ink cannot be used on paint. Ink lines drawn over a poster-painted surface won't adhere. If you want to make a black line over white paint, you must use black poster paint, not ink.

Rubber Cement

Rubber cement is the adhesive you'll use most frequently; it is efficient, flexible, easily applied, thickened, thinned, and removed. In Chapter 7 you'll find an extensive description of how to work with it. Because cement is used so often, buy it by the quart. Also purchase a quart of thinner and a pint-size rubber cement dispenser with an adjustable brush attached to the lid for easy application. Use thinner to remove what has already been cemented. You can apply it to the area by pouring it from the spout of a can designed for this purpose. You'll also need thinner to bring the cement to a consistency suitable for use. If you happen to over-thin—thereby reducing the adhesive power of the cement—add more cement or let the thinner evaporate.

Remove dried cement with a pick-up that you can purchase, or create one of your own by rolling a ball of dried rubber cement between your fingers.

Rubber cement, thinner, and other adhesives have been developed for the pasteup artist. Specially designed dispensers for the cement and thinner are advisable.

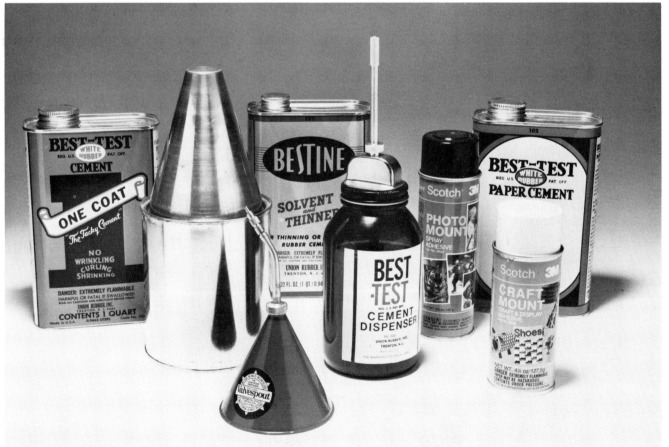

Self-adhesive tapes will be required in almost every job: transparent, white masking, border, and register tapes.

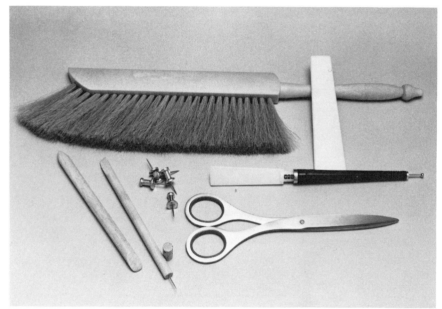

These assorted tools will come in handy: dusting brush, push pins, burnishing sticks, scissors.

Tape

White masking tape is another adhesive you'll use frequently. Self-adhesive and reusable, the paper tape serves many functions. With it you can cover an undesirable spot, make durable hinge flaps, hold your work down on the drawing table, or create a stick-proof surface for applying cement. Another advantage is that you can write on its surface with a ballpoint pen. You'll also find use for cellophane tape, particularly the matte surface tape that you can write on. The ½″ sizes in both are recommended.

Miscellaneous

If the substantial size of a well-equipped art supply catalog is any indication, you can see how easy it is to get carried away with an assortment of materials and tools. It's important to have the right tool for the right job, but you needn't feel the pressure of many more accessories other than those discussed here. A dusting brush may be handy for removing particles of eraser crumbs from a surface, and perhaps you should have a supply of push pins, a pair of scissors, fixative, a pencil sharpener, a pencil holder, and a sandpaper block or pad. You'll need a jar for water and a supply of rags, and for close examination of proofs you may find a printer's magnifier useful. For certain mechanicals you may be required to use masking films, which are described in greater detail in Chapter 8. But it will be some time before this type of work is on your drawing table. Until then, purchase only those supplies you are certain to require for the work at hand.

Illustration Board

Illustration board is simply cardboard on which drawing paper has been mounted. The surfaces are smooth (hot pressed), toothy (cold pressed), or rough. The smooth illustration board is the most practical for your purposes: being free of any texture, the surface is more sympathetic to all the tasks you are likely to perform in preparing art for reproduction.

Overlays and Papers

To protect your mechanical or give instructions to the printer, you'll need overlays. For a so-called *tissue overlay*, *visualizer paper* is recommended. It is pliable and translucent and comes in pads of various sizes. For a so-called *copy overlay*, acetate sheets are used.

Acetate is a transparent sheet of plastic, obtainable in several weights. If you intend to write on or mark the acetate, be certain to purchase the treated variety that will accept ink.

For protective overlays, select any sheet of heavy paper, hinged to the illustration board with masking tape, that will protect the surface of the pasteup from damage.

Finally, it would be useful to have a pad of tracing tissue on hand as well—a lightweight paper that you use for layouts and scaling art.

Organizing Your Work Area

Once you have your materials and tools assembled, set up the work area for maximum efficiency. Here are a few tips that may save you time and energy:

1. Adhere a protective sheet of illustration board or a sheet of vinyl plastic over the drawing board. Be certain this sheet is placed along the extreme left (or right, if you are left-handed) of the surface, because you'll be working close to the head of the t-square for greater control of the instrument. Adhere the board or plastic squarely to the drawing board with tape.

2. Reserve the opposite side of the drawing surface for tools you'll be using for the job at hand. To prevent these tools from sliding off, attach a thin strip of wood to the bottom edge of the drawing board, if such a strip is not already there. If you need a liquid container (such as an ink bottle) on the board, cut an opening in a strip of paper, slip that over the top of the bottle, and attach the two ends of the paper to the board with tape or thumbtacks.

3. Lay out your tools neatly on the right-hand side of the board beyond the reach of the t-square. (If you place your tools too far toward the center of the board, you will continually knock them over with the t-square.)

4. A rag tacked to the right edge of the board will come in handy for wiping off ink from your pen or spilling accidents that may occur.

5. The proper chair designed for studio work enables you to swivel from the taboret to the board. You can also adjust the height of the seat and the firmness of the back support to permit you to work in maximum comfort for many hours. Be certain that you can easily reach any portion of the work area without strain.

The importance of a well-organized studio cannot be overemphasized.

CHECKING FOR ACCURACY

1. To check the accuracy of the horizontal alignment, draw two parallel lines on a sheet of paper attached to the drawing board. Use the t-square as a guide for both lines.

2. Measure the distance between the two lines at the left.

3. Measure the distance between the two lines at the right. The two measurements should be equal. If they are not, the drawing board is not square.

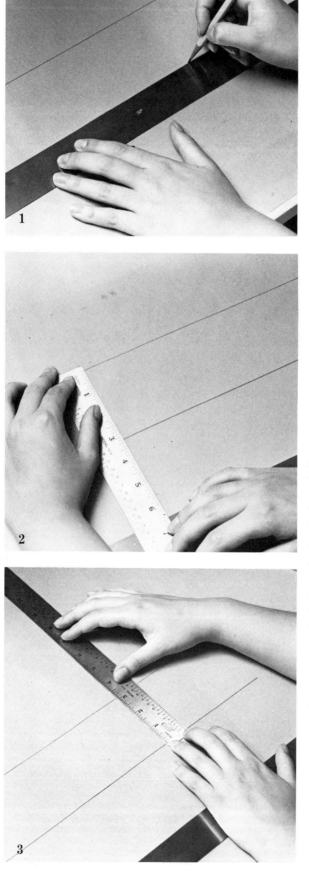

Checking for Accuracy

Your drawing board should have a *true edge*, or metal strip along the left-hand side (or right-hand side, if you are left-handed). Even if it does not, you need to be certain that the board is *true*, that it is square, so that your work will be accurately aligned.

To check the accuracy of the horizontal alignment, draw two parallel lines on a sheet of paper attached to the surface. Hold the t-square with its head flush against the left edge of the board. Draw a horizontal line at the lower portion of the paper, using the t-square as a guide. Now slide the t-square up the edge of the board and draw a horizontal line at the upper portion of the paper. Measure the space between the two lines. First measure the distance between the left ends of the line; then measure the distance between the right ends of the line. If the distances are precisely equal, your board is true. If they are not, the metal edge of the board must be adjusted until the two lines are equidistant at both ends.

Now that you know the horizontal is accurate, check the trueness of the vertical lines. Place the t-square in position at the lower edge of the paper and set the edge of the triangle on the edge of the t-square. Draw a vertical line, following the edge of the triangle as a guide. Then turn over the triangle and place the edge along the same line you have just drawn. Draw a new line over the old one. If the two lines are identical, your vertical is accurate.

Preparing well in advance, using these suggestions, will prevent errors from occurring at a later time. A well-equipped and well-organized studio is critical for the work that lies ahead.

4. To check the vertical alignment, draw a vertical line at the right side of the triangle, with the base of the triangle resting on the t-square.

5. Turn over the triangle and place the left edge along the same line. Draw a new line over the old one. If the two lines are identical, your vertical alignment is accurate.

3: BASIC INKING TECHNIQUES

Holding the pen in a vertical position, squeeze three or four drops of ink from a dropper into the blade of the pen.

Wipe away excess ink from the ruling pen.

There are many occasions when it is necessary to create rules, borders, circles, or other line indications. Doing these with a ruling pen, brush, or compass requires skill. Here you'll learn how to use the proper instruments for every task you're likely to encounter when preparing pasteups and mechanicals.

Filling the Ruling Pen

The ruling pen has been designed to retain a marking fluid—watercolor, ink, or dye—and deposit an even line. It is not designed as a free-handed tool and is normally used in conjunction with a supporting edge, such as a straightedge or a flexible curve ruler.

With your left hand, hold the pen in a vertical position, point down, the blades close together. Take a dropper charged with ink into your right hand and squeeze three or four drops of the liquid between the blades, an amount that extends about ½″ up from the point. (It's advisable to perform this operation over a wastebasket in order to catch any droplets of ink that may accidentally spill over.) With a rag, gently wipe away any ink that may have been deposited on the outer surfaces of the blades. Adjust the thickness of the line by turning the control knob. Try out the line on a piece of scrap paper, increasing or decreasing the thickness until you obtain the size you need.

Drawing the Rule

Place the straightedge slightly below the pencil line to be inked. Resting your fingers on the surface of the straightedge, hold the inked ruling pen—control knob facing out—perpendicular to the edge. Then lean the pen back slightly, so that the pen point touches the pencil line and creates a small space between the tip of the pen and the supporting straightedge. Tilt the pen slightly toward the direction of the stroke. Applying minimal pressure, slide the pen along the edge in a single, smooth movement. The ink should flow smoothly and evenly without the use of much downward pressure. When you reach the end of the line, turn your wrist to lift the pen away from the surface.

This is the method of achieving a clean, accurately placed rule. If the pen is tilted too far forward—away from you—the blades will pull under the straightedge and the ink will spread under the edge. If the pen is tilted *back* too much—toward you—the ink coverage will be insufficient, creating a broken line. If the pen is tilted too much toward one side, it will make poor contact with the paper and the line will be inaccurate. Repeat: lean the pen slightly back and toward the stroke for best results.

To draw vertical lines, you may either turn the paper 90° or use a triangle. Vertical lines should be drawn away from your body, with your shoulders placed parallel to the line being drawn. For better

Practice with the ruling pen on a sample piece of paper until you have achieved the line thickness you need for the job.

With the pen's control knob facing out, place the blades of the ruling pen against the straightedge and lean the pen back slightly towards you. There will be a small space between the point of the blades and the straightedge.

visibility and greater physical comfort, draw vertical lines along the left edge of the triangle — rather than along the right — and turn your body so that your position is relatively parallel to the line. (Be careful not to lay the triangle over linked lines that may still be wet!)

Because of the shape of the pen point, the ends of a line are rounded rather than square. To create a squared edge at the beginning and end of the line, draw the lines longer than necessary and shorten the rules to size with white opaque paint. If you're drawing a rule on high-quality paper, you may also square off the edges of a line by scraping away the ink with a razor blade.

Tilt the pen towards the direction of your stroke and slide the pen along the edge in a single, smooth movement, using minimal pressure.

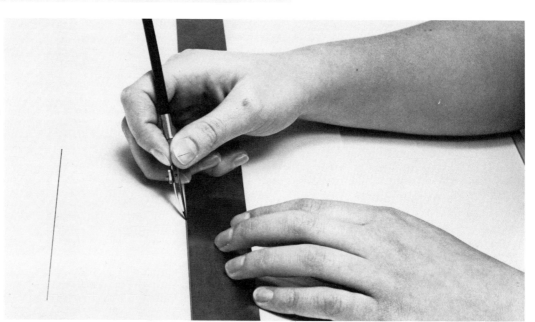

Here the pen is held too far forward, away from the body.

Right:
To draw vertical lines, place a triangle along the edge of the t-square and draw away from your body along the left edge of the triangle. Turn your shoulders so that they are roughly parallel to the line.

Far right:
To draw clean, square corners, extend the lines beyond the desired point and paint out the excess lines with opaque white.

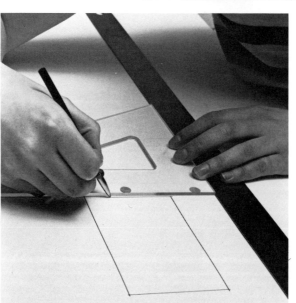

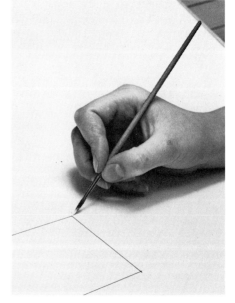

In the same way, square corners are most effectively achieved if you extend the lines beyond the corners and shorten them to the precise length with opaque white. Here again, if you're working on good paper, you can have good results by placing one razor blade against the outer edge of the corner and scraping away the excess rule with another blade.

To extend a short line, first determine the proper thickness of the rule by matching up the point of the empty pen with the line. Then place the straightedge slightly below and parallel to the short line, and with the charged pen, begin the stroke to the left of where the extension begins. With a smooth, continuous movement of the pen from the short to the extended line, you can create a clean and even juncture.

Heavy Rules

If your ruling pen is incapable of producing a line thick enough for your purposes, don't try to force a wider line than the tool will permit. You'll obtain better results if you build up the line in several successive strokes.

For an especially thick line, draw two parallel, narrow rules and fill in the space between the rules with an inked brush, a ruling pen, or a small technical nib.

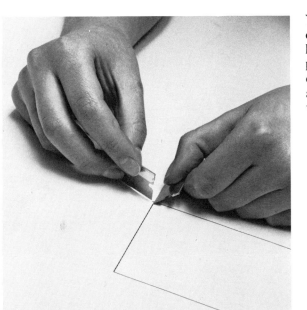

You can also obtain a clean corner if you hold one razor blade precisely at the corner and scrape away the excess line with another blade.

To create heavy rules, draw two parallel lines and fill in the space with a ruling pen.

For a heavy rule you can also use a technical pen with a small nib to fill in the space between the parallel lines.

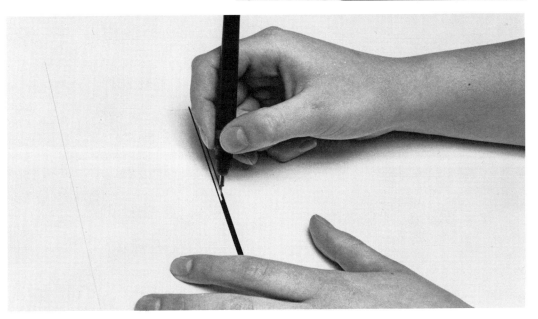

To create dashes, draw a solid rule first. Tape a ruler above and parallel to the rule. Slide the triangle along the t-square, lining up the desired intervals with the ruler to establish precisely measured breaks. Mark these in a sharp pencil.

Using a fine brush, white out the spaces in the line at the intervals indicated by the pencil lines.

Right:
A drop compass is best for creating small circles.

Far right:
A bow compass is a good all-purpose compass. Here it is shown with a ruling pen attachment.

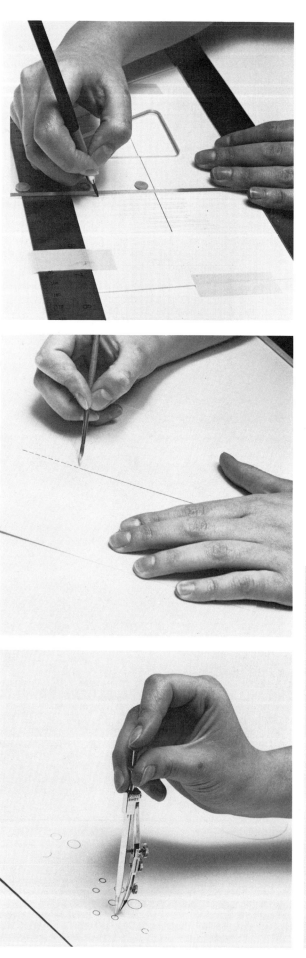

Broken Rules

To obtain a dash line, first ink in a solid rule, then opaque out the spaces in regular intervals, following a penciled indication of where they occur. To establish regular intervals, tape a ruler above and parallel to the rule and slide your triangle along the t-square, lining up equal intervals on the ruler and drawing vertical lines at those points on the solid rule. This method is far easier than trying to rule equally drawn and spaced dashes.

Creating a broken rule may require practice (and patience) because the dashes at either end of the rule should be equal in length to the other dashes throughout the line, which is more easily said than done. (In Chapter 10 you'll find some suggestions about dividing a rule into equal spaces.) The likelihood of error is great enough that many artists prefer using dry transfer type for broken rules.

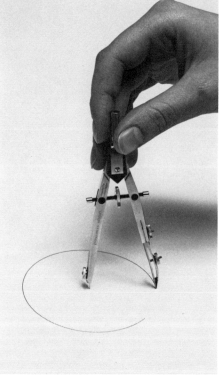

Drawing Circles

A compass is required for drawing circles. The type of compass you select depends on the size of the circle itself. A drop compass is best for small circles, an ink bow compass for larger circles, and a friction compass for very large circles. Regardless of the instrument, the principles of its use are the same. First establish the line width on a scrap of paper. Locate the center of the circle with the needle and extend the drawing leg to the desired radius. Held with the thumb and index finger, the compass is swung around in a circle that pivots on the needle. Don't lower the marking leg until you have established a smooth movement in a clockwise direction. As you turn, lean the compass in the direction of the turn and lower the marker to the surface, continuing to swing the instrument in a smooth movement. Don't interrupt this movement. The circle is made in a single continuous stroke. Complete the circle and continue slightly beyond to create an even juncture.

Like the ruling pen, the compass must be cleaned immediately after use to prevent the ink from encrusting the instrument.

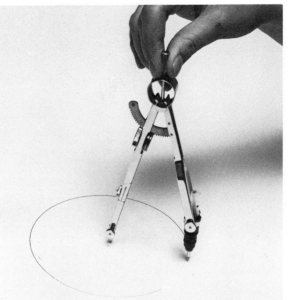

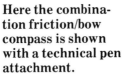

Here the combination friction/bow compass is shown with a technical pen attachment.

Here the bow compass is shown with an extension arm attached to make larger circles.

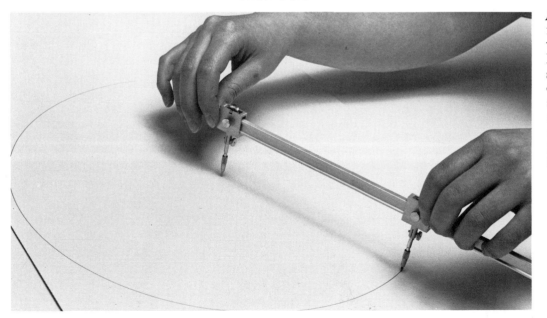

A beam compass is used for drawing very large circles. Regardless of the instrument, the procedure is the same: swing the compass in a smooth, continuous movement, completing the circle in one stroke.

Rounded Corners

There are a number of instances where rounded corners may be required in preparing art for reproduction. A corner that is well rounded has an exact, symmetrical curve and connects smoothly with the straight lines on each side. Accomplishing both feats—an exact curve and a smooth transition—means mastering basic techniques.

Establishing an Exact Curve

Using your t-square and triangle, indicate the square or rectangle in pencil. Now bisect each corner. If you're using a 45° triangle, you can simply align it so that the 45° angle precisely intersects the corner. Draw a pencil line through the angle.

If you're not working with a 45° triangle, you can use one of two methods to bisect the corner. (For greater clarity, we've focused on only one corner.) You can draw two

To round a corner, first draw the square or rectangle in pencil. Then bisect the corner, using one of two methods. Here's one method: draw two lines, each equidistant from the corner, to form a square. The larger the square, the larger the sweep of the curve at the corner. (Be sure the square is the same size at each corner.)

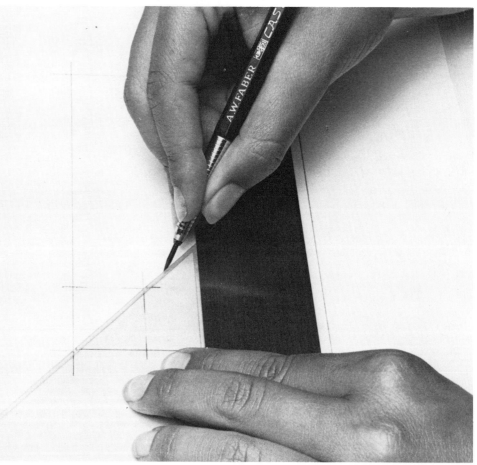

With the triangle as a guide, bisect the square by drawing a diagonal from the inside to the outside corner.

lines at right angles to the sides of the straight lines, each equidistant from the corner, constructing a perfect square. (The larger the square, the greater the arc at the corner. Be sure the square is the same size at each corner.) Using your rule and triangle as a guide, draw a pencil line through both corners.

You can use another method for bisecting the corner, one that is also used for creating perfect right angles as well. Simply place the pencil of the compass on a corner and the pivot point of the compass on one of the sides of the rectangle. Now inscribe an arc through the corner and into the interior of the rectangle. Repeat this procedure at the adjacent side of the rectangle, intersecting the opposite arc. (Your compass may be set to any radius as long as the arcs form an intersection.) With a straightedge as a guide, draw a pencil line through the corner and intersecting arc. Now the corner angle is bisected.

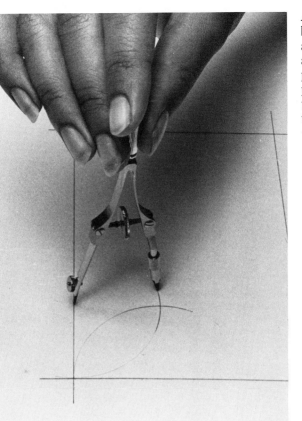

Another method of bisecting a corner is as follows: draw two arcs with a compass, placing the pencil point on the lines of the rectangle, so that the arcs intersect within the rectangle.

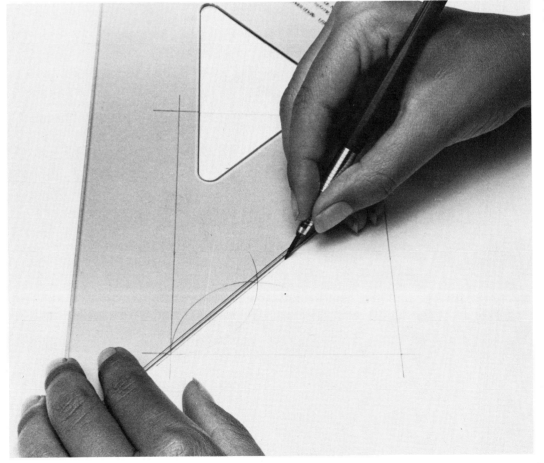

Draw a diagonal line through the points where the arcs intersect. The right angle is now bisected.

Set the needle of the compass anywhere on this diagonal line, the pencil point touching the straight lines that make the corner. (Just where you place the compass or pivot point on the line will determine the radius of the curve at the corner.) Lightly pivot the compass, scribing a semicircle as the pencil swings from one side to the other. The arc forms a rounded corner as it blends with the straight lines. Repeat this procedure for each corner.

Inking in the Rounded Corners

The trick in inking the corners is to blend the curved line into the straight lines with no visible juncture. First ink the curved lines (*not* the straight ones), following the penciled curves. Set the needle into the hole already made by the first compass operation and follow that curve precisely, without continuing it beyond the points where it intersects the straight lines. Repeat this until all four corner curves are inked.

Now connect the curved lines with the straight lines. With the t-square, line up the ends of the inked curves and connect them, even if the rule is not lined up precisely on your original penciled line. No one will notice if the inked line fails to follow the pencil line precisely. It's more important that the inked lines blend properly. Some skill and patience is required to achieve the same thickness of line when switching from your inking compass to your pen. A nib that can be used in both compass and ruling pen is helpful here, since only one thickness setting would be required.

Incidentally, inking with a ruling pen and inking compass is shown here because we think it's important that you master these tools completely. Reservoir-type inking pens might seem easier to use, but a different nib is required for each line thickness. This can be restricting (and costly). If you develop the skills needed to use the basic ruling pen and inking compass, you'll find it more convenient in the long run.

Now round the corner. Place the point of the compass on the diagonal line opposite the corner and draw a curve that touches both sides of the rectangle. The degree of the curve will be determined by where you place the point of the compass on the diagonal line.

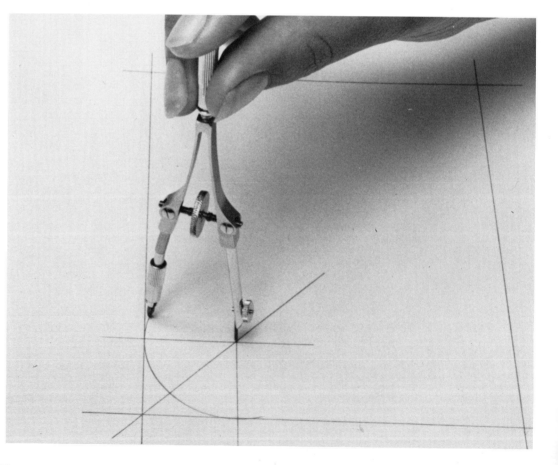

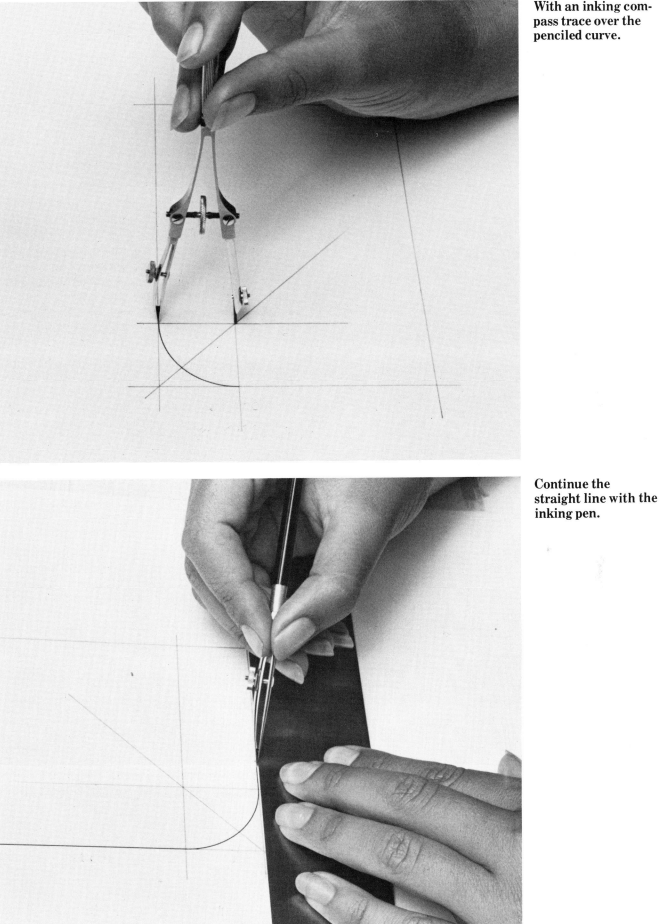

With an inking compass trace over the penciled curve.

Continue the straight line with the inking pen.

4: ART AND REPRODUCTION

Not all art drawn in line is actually line art. To the right is a drawing made in ink that is line art. Below is a pencil drawing that was done in line, but because of its tone, it cannot be considered line art. To the right of this drawing is an ink drawing that was screened to achieve a gray effect. And still another, screened for an even more gray effect, is shown alongside.

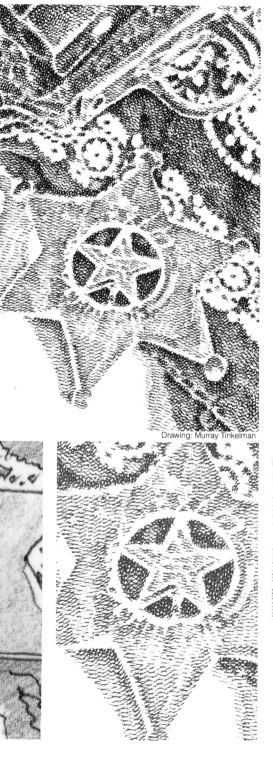

Drawing: Murray Tinkelman

If you've carefully practiced the procedures for inking just described in Chapter 3, you've acquired skills necessary for creating expert line work. Inked lines are one of the three basic ingredients required in preparing art for reproduction. The second major ingredient is the illustrative material contained in the to-be-printed piece, material that is generically referred to as the *art*. (Studio parlance can be confusing. You'll find that it's common practice to refer to *all* material—manuscript, type, and art—as *copy*. Here we distinguish each of the three elements to avoid any confusion among them.)

Art comes in two basic forms: line and continuous tone. Either form can be printed in black and white or in color. Beyond these very broad categories is a whole variety of ways in which art can be reproduced. In this chapter we'll present the many ways in which line or

continuous tone art can be reproduced, and in the next chapter we'll describe how to *prepare* each type of art for the printer in order to achieve the printed results shown here.

Line Art

Line art is the term used to describe art that is black or white, with no gradations in between. (It's also called *flat art*.) But not all art drawn in line is line art. In fact, a pencil line is not necessarily line art, because the graphite mark contains shades of tone that graduate from black to gray to white, depending on the degree of pressure applied, the degree of hardness of the pencil point, and the degree of texture in the paper. Ink lines, on the other hand, create a single tone whose opposite is the white drawing surface itself. They can therefore be considered pure line art.

Line art can be created with a pen, a charcoal pencil, a grease pencil, or a brush; or you can use the so-called scratchboard technique, in which white lines are scratched into a specially coated black surface. Line illustrations can be woodcuts or engravings, stippled or spattered, brushed or ruled.

The printer's camera photographs the line art in the size you indicate, creating a film negative (like that in any camera) and later a line plate from the negative, which is like a photographic print made on metal. The camera can also photograph line art through a screen, if desired, to achieve a gray or lighter effect. Line art can be reversed (black becomes white and white becomes black), and it can be flopped, reversing the direction of the illustration. Line art can be reproduced in any color simply by selecting another ink, and if a second color is available, a colored tint may be placed behind the line art.

An ink drawing has been reversed to produce a white line on a black ground.

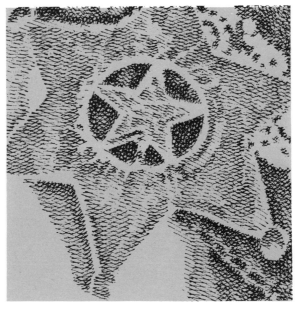

Here the ink drawing is flopped, left to right.

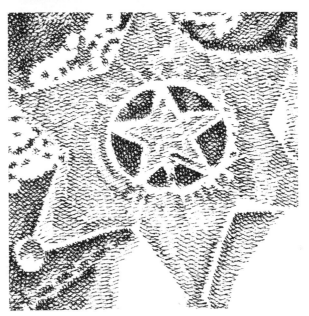

Here the ink drawing has been reproduced with a tint placed behind it.

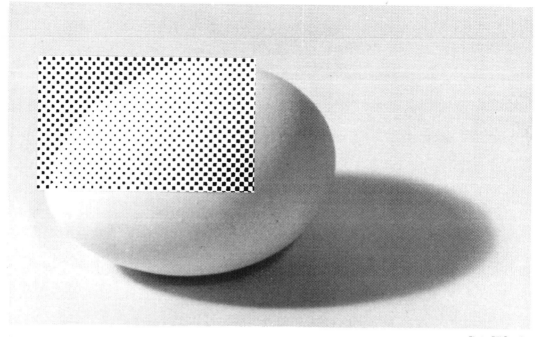

Photo: Bill Copelan

Continuous Tone Art

Unlike line or flat art, continuous tone art has values of gray that vary between the extremes of black and white. Photographs are the most common form of continuous tone art you're likely to handle. The vast tonal range in a photograph is created by light falling upon and triggering a photochemical process in a specially treated, light-sensitive emulsion. The same photographic process cannot be directly applied to the printing process that uses *inks* to create images, because the printer's film only registers black and white. How to obtain gray tones by stamping black ink lines onto white paper posed one of the great challenges to the printing industry. Until the 1880s, all art reproduction was created by wood engraving. Lines were engraved into a closely grained type of wood, and the raised portion of the wood block carried the ink and, when stamped on the paper, left an impression, much like the principle of today's rubber stamps. The illusion of tone could be created by a skilled engraver, capable of cutting into the wood minute lines or dots side by side. The farther apart the lines or dots, the lighter that portion of the picture; the closer and denser the lines or dots, the denser the black.

The accurate reproduction of continuous tone art by means of a photomechanical process, invented at the end of the 19th century, represents one of the greatest breakthroughs in printing technology. The hand work of the engraver was replaced by a photographic system in which continuous tone art could be photographed through a screen. This screen breaks up the tones into densely or sparsely placed areas of dots that—when seen from a distance—give the illusion of a continuous tone. Actually, the continuous tone is only a series of inked lines or dots. In printing, these are referred to as *halftones*. Look through a magnifying glass at continuous tone copy—a printed black-and-white photograph—reproduced on a printed page and you'll see a mass of tiny solid dots.

Halftone Screens

Continuous tone art is photographed through a special screen, called a *halftone screen*, inscribed with many fine lines that criss-cross at right angles. The number of fine lines per square inch (referred to as *screen count*) can vary from one screen to another, ranging from 55, 65, 68 to 100, 120, 133, 150, 175, and even 300 lines per square inch. The higher the number, the more lines per square inch, and the greater the number of dots. The more dots there are, the smaller they become and the greater the resolution (range) of tones. A halftone designed to be reproduced on a lower grade of paper is generally photographed through the coarser screen (65 line, perhaps). The smaller dots created by a finer screened halftone would tend to fill in with ink, losing detail on a coarse paper. For example, a newspaper photo is generally screened at 65. Fine art reproductions might be reproduced with a 300-line screen.

Here is a single halftone image reproduced in several screens.

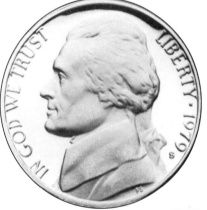

100-line screen.

120-line screen.

55-line screen.

133-line screen.

75-line screen.

150-line screen.

Square halftone.

Square Halftone

The most common method of reproducing continuous tone art is as a square halftone. Here the reproduction is squared off — right angle corners — to a square or rectangle and the entire surface of the image carries a dot formation. It is also possible to request that a halftone be shaped into a geometric shape — an oval, perhaps — with the dot formation continuing out to the edges.

Silhouette Halftone

If a white background is desired, it is possible to eliminate that portion of the art and *silhouette* only the desired shape so that it floats on the page. The halftone dots are removed from the background by the printer by hand or by masking. (This is also called an *outline halftone*.)

Silhouette halftone.

Dropout Halftone

In a normal halftone, there are dots in even the lightest area of the image. By removing these dots the highlights become more vivid. Also called a *highlight* halftone, the dots in the dropout halftone literally "drop out" from the highlight areas. (This is generally done by the engraver.)

Vignette halftone.

Vignette Halftone

The edges around the halftone can be shaped and blurred to form a *vignette*. The effect of a fading edge can be done with an airbrush in the studio or by the printer using a mechanical process.

Combination Line/Halftone

Line can be incorporated into a halftone image. The line and the continuous tone are photographed separately and then combined into a single unit. By separating the line from the halftone, the printer holds the solid line of one and uses the screen from his halftone for the other, maintaining the integrity of each. The line can be printed alongside the square, silhouette, dropout, or vignette halftone, or it can be printed over (surprinted) or dropped out of a halftone.

Dropout halftone.

Combination line/ halftone, type dropped out.

Combination line/ halftone, type sur- printed.

Like halftones, velox screens come in a variety of sizes. 27-line screen velox.

Veloxes

Normally a halftone is made by the printer. The art is photographed through a screen to obtain a film negative, which is then stripped into the negative containing the other elements to be reproduced on the same sheet. A less costly method of obtaining a halftone—though not creating as high a quality reproduction—is with a *velox*. This is a screened, paper photographic print of the continuous tone art, in which the continuous tone art is converted into line art.

To have a velox made, you must send the art to a graphic arts studio specializing in this procedure. The art is photographed through a screen to the size you request as a halftone negative and then printed as a positive on photographic paper. This velox can then be pasted into position directly on the mechanical, and the printer can simply photograph the entire page. The type and halftone converted into a velox require only a single shot, without the added step of stripping the halftone element in with the line art at a later stage.

Like the halftone, the velox can be prepared in a variety of screen sizes (50, 80, etc.) and can be printed as a dropout or silhouette if you so desire. Like line art, the velox can be retouched with white or black paint in your studio, giving you greater control over its treatment.

55-line screen velox.

85-line screen velox.

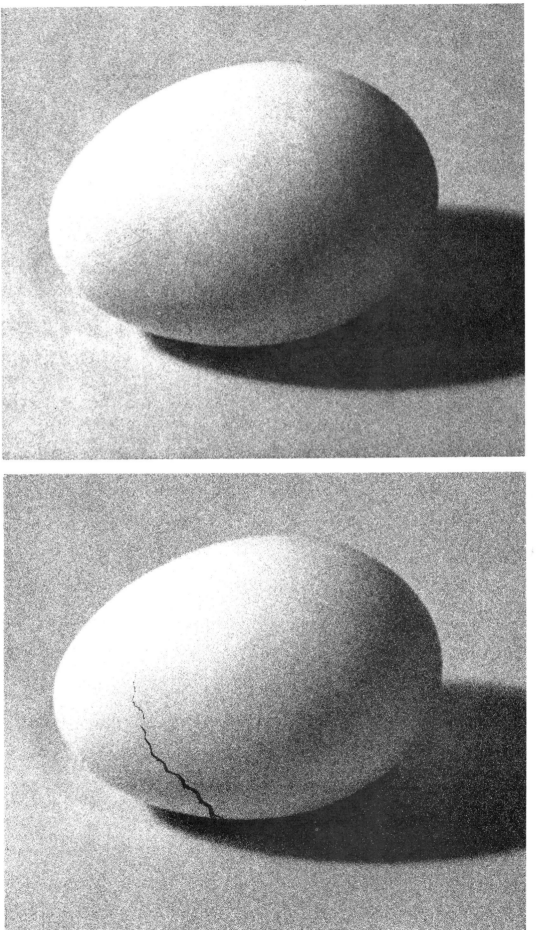

Like all line art, veloxes can be re-touched. This velox is reproduced un-retouched.

Retouched velox.

Special effects created with line conversions, using a method called *Laser Line*.

Horizontal line.

Special Effects

Many graphics studios are also capable of creating other kinds of line conversions from continuous tone copy, using even more unusual screen patterns. The art can be photographed through a concentric circle screen or horizontal wavy lines, with a simulated woodgrain or a cross-hatch, to name only a few of the types of line conversions available. If not overdone, the line conversion is a clever method of extracting unusual effects from continuous tone copy.

Needle point.

Mezzotint.

Posterization.

Flat Tones

Not all tones are continuous. A tone can also be flat. In reproduction, a *tint* is a flat tone of color. Remember, in halftone reproduction, the number and density of the dots vary according to the light or dark passages of tone. A tint, on the other hand, is created by a regular pattern of dots, each of equal size. If the color happens to be black, the tint will be gray. The degree of gray value is determined by the number and size of the dots in any given tint. Each value has its own dot size, and the dot size is the same for each tint. The larger the dot, the deeper the tone of gray and the less white area; the smaller the dot the lighter the tone because the white area is greater. Tints are designated by the percentage of solid black: a 5 percent tint produces a very light gray, and a 90 percent tint produces a dark gray, with many degrees between. A solid black is a flat, unscreened tone.

Any color can be screened to create different values of the same hue. A halftone may be printed over a tint, and type or line copy can be printed over or dropped out of a tint.

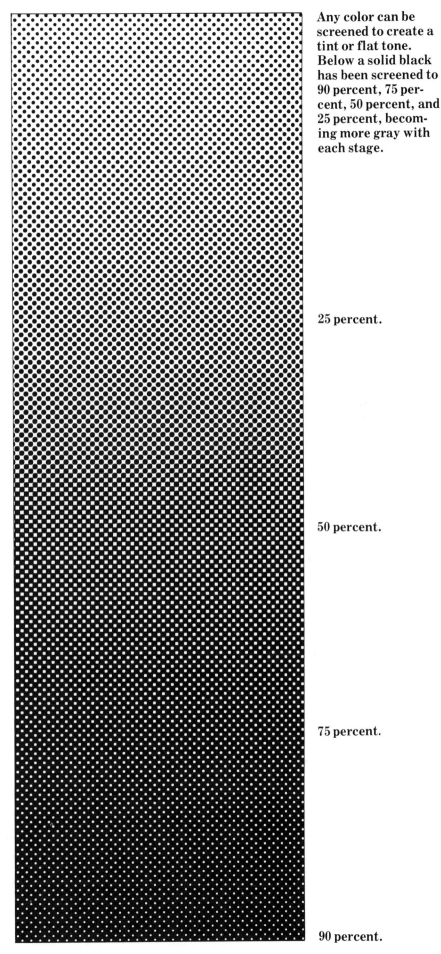

Any color can be screened to create a tint or flat tone. Below a solid black has been screened to 90 percent, 75 percent, 50 percent, and 25 percent, becoming more gray with each stage.

25 percent.

50 percent.

75 percent.

90 percent.

Shading sheets come in a variety of patterns.

Concentric circles.

Random stipple.

Wavy lines.

Stipple.

Shading sheets used here to create a simple bar chart.

Benday and Shading Sheets

As we described above, line art can be converted to a tint with screens, just as continuous tone art can be converted to line with veloxes. Traditionally the screens used for tints were called *Benday* screens (named for its inventor, Benjamin Day) and the operation was performed manually by a Benday artist. At the printer, the Benday artist presses a screened film over the portion of art to be reproduced as a tint. Now the process of screening these areas has become so mechanized that the art can simply be photographed with the appropriate exposure and screen to obtain the desired tint automatically. The term "Benday" is still used for this operation, although the process itself is seldom used.

It is also possible for you to create screened tints in the studio with shading sheets (often called *Benday shading sheets*). The desired tone percentage is printed on pressure-sensitive plastic sheets with a release paper backing. Applying the shaded areas in the studio is an inexpensive way of achieving flat tones and is frequently used in creating charts, graphs, or cartoons for reproduction.

Color

Until now we've described art reproduction for all single- or multi-color printing. The introduction of color creates another element in the printing process, and will therefore influence your preparation of the art for reproduction.

Color may be *substituted* for black ink and still be regarded as single-color printing. More than one color can be used, of course, which will increase the cost and complexity of the job. Two-color printing is the most common type of printing you'll probably encounter. With color there are a number of effects you can achieve: the color can be printed in flat tones, solid, or tints with screens. The more colors you have available, the greater the variations possible (and the greater the cost, naturally).

Here we will describe some of these variations.

Line printed in solid colors and in tints.

Duotones in various screens.

Full black, 20 percent blue.

Full black, 50 percent blue.

Full black, 80 percent blue.

Duotones

Remember that a *tint* is a flat application of a screened or solid area of ink. Although a *duotone* introduces a second color, it's not flat color. The duotone is incorporated into the actual preparation of the halftone itself. Like the halftone, the duotone contains dots of different sizes and density to convey a tonal range. A second color used for a duotone creates a rich halftone, desirable when certain effects may be required.

The duotone is prepared in the camera room, where the halftone is shot twice, with the angle of the screen shifted slightly so that the dots do not overlap when placed one

High-contrast black, 50 percent blue.

over the other. For the first shot, the camera is adjusted to concentrate on the dark tones in the art that will be printed in black. For the second shot the camera is focused to concentrate on the lighter and middle tones for the second color. Two negatives and two plates are created for the duotone. The amount of second color introduced can also vary, depending on the size of the screen used for this process. For example, it's possible to have a full black tone but only a 20 percent for the second color. Likewise, the art can be shot for an 80 percent of the second color if more color is desired for the duotone. By combining these two in the printing process, a deep range of tones is created.

Full blue, 20 percent black.

Full blue, 50 percent black.

High-contrast blue, 50 percent black.

Full blue, 80 percent black.

Sections from four-
color progressives
and inks shown at
full value.

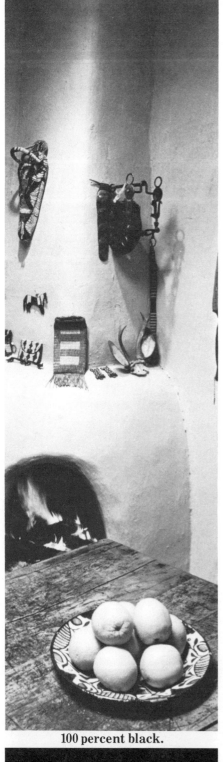

100 percent black.

Process Color

We've considered single-color and two-color work that can be reproduced in line or in halftone. What remains is reproducing continuous tone art in full color. The number of colors used for printing can be limitless, of course, but that kind of color printing can be very costly. Technological advancements introduced several decades ago have made it possible to achieve most full-color effects simply with the use of four colors, the three primary colors plus black. Called the *process* colors, these four colors are red (magenta), yellow, blue (cyan), and black.

According to traditional practice, the color art is placed in front of the camera and photographed four times, with filters to extract only those four colors. After each shot the negative is removed, the screen turned slightly, and another filter placed in the camera until the art has been photographed with all four filters and at different screen angles. Four negatives (or separations) are obtained that are then developed and printed on four separate printing plates, one for each color. Each plate is inked with the appropriate color and printed. What results is one of the great marvels of printing technology: a full-color image. Because the screens have been angled, the dots fall into patterns (called *rosettes*) side by side. These colors merge optically — much like the optical mixing of colors created in paintings by the pointillists in the late-19th century.

Great advances in printing technology are being made in color work, and much of the art is now separated automatically by computer with so-called *color scanners* performing the work once performed by an individual. With advances in technology, the cost and complexity of color printing will change, but the principles will remain the same.

On the pages that follow you will find several variations on the treatment of art in reproduction.

Line conversion in two colors.

Line conversion in two colors with tint.

Black line conversion surprinted on solid blue, with type-dropped out of black.

**Black and white
halftone.**

Here a 100 percent
black line conversion
has been surprinted
on a solid blue panel,
with an inset printed
in duotone.

5: WORKING WITH THE ART

From layout to pasteup you'll be working with a good deal of artwork. In this chapter we'll describe how to handle the art, how to scale it to size, and how to prepare the art for reproduction.

How to Handle Photographs

Before a job is completed, photographs will pass through several hands, so be sure to protect them for their journey. Here are some general rules about handling them:

1. *Avoid Fingerprints:* Hold the photograph at the sides, along the edges, to prevent your fingers from making contact with the picture surface. Deposits of oil left on the photo from fingerprints may be undetectable to the eye, but evident on the final reproduction.

2. *Prevent Indentations:* Do not use paper clips directly on the print; don't write on the surface or the back of the photograph with a hard pencil. Don't stamp the back of photographs. Dents will be apparent in the final reproduction.

3. *Prevent Surface Cracks:* Don't fold photographs; don't crowd them in a drawer where they may be damaged. Don't place photos face to face where particles may gather in between. If you must roll photographs for shipping in a tube, always roll them with the image on the outside to prevent the emulsion from cracking. (It is, however, preferable to mail photos flat, sandwiched between two pieces of cardboard larger than the art itself. Corrugated boards are best for mailing, with the corrugations of the two boards placed at right angles to each other, if possible.)

4. *Prevent Stains:* Have your coffee breaks elsewhere. You can cause burns and stains inadvertently if a cigarette or beverage is in proximity to the art. Be especially careful not to place anything on top of the photograph. Retouched photographs are particularly susceptible to staining and smearing. With these it is even recommended that you avoid coughing or sneezing over the surface of the photograph.

To prevent indentations, write on the back of the photograph only with a soft pencil and place a protective piece of paper between a paper clip and the photograph itself.

Far right:
To prevent damage when sending photographs, pack them between pieces of corrugated cardboard.

Mounting Photographs

The photograph is protected most effectively when it's mounted on an illustration board larger than the print to facilitate handling and to permit marking. Before mounting, be certain to transfer to the board any information indicated on the back of the photograph. Also be certain to remove any labels pasted on the back of the photograph.

Dry mount the photograph on the board. Apply rubber cement to the back of the photo and to the surface of the board and allow both to dry. Now use the so-called *slip sheeting* method of adhering the photo to the board. Lay a sheet of tracing paper on the cemented board, leaving an edge of cement exposed. The tracing paper will not adhere to the dried cement. Position the photo on the board, laying its edge on the exposed edge of dried cement. Press down along the edge of the photograph and gradually withdraw the sheet of tracing paper from beneath the print, pressing the photo into the dried cement as you pull away the tissue, until the entire surface is pressed flat against the cement. Place a tissue over the photograph and press it flat with the edge of a triangle to burnish. Remove the residue of cement that's dried around the edges of the photograph. Finally, lay a sheet of tracing paper over the photograph and attach the upper edge to the board with masking tape to make a tissue overlay. This protects the surface of the photograph and provides a surface for making notations and indicating approximate crop marks.

Buckled and Curled Photographs

If you mount a buckled photograph on a board, remove the wrinkles carefully as you withdraw the tissue from beneath the print by pressing the surface with the flat edge of a triangle. Be sure to put a sheet of tissue over the photograph to protect it from being scratched as you rub with the triangle.

1

2

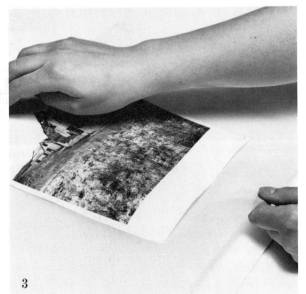

3

1. To paste up a photo on a board, cement the board and the back of the photo and allow each to dry. Place a piece of tracing paper (*slipsheet*) on the board, leaving the upper edge of dried cement exposed. Lift the photo by the edges and place it over the board and slipsheet.

2. Tack the upper edge of the photograph along the upper edge of the dried cement on the board.

3. Gradually withdraw the sheet of tracing paper from beneath the print as you press down along the edge of the photograph.

4. Place a clean sheet of tracing paper over the photograph, and *burnish* the print with the edge of a triangle until the entire photo is in tight contact with the board.

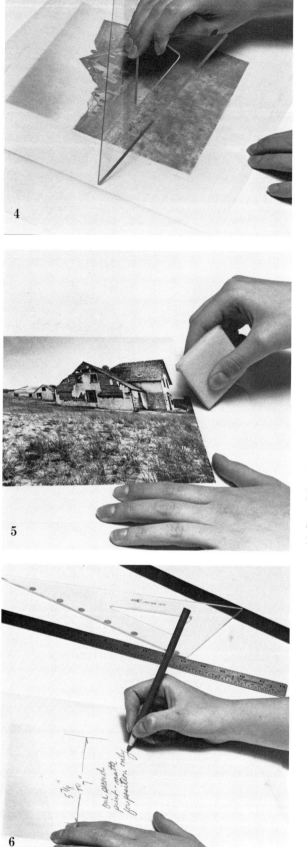

5. With a cement pickup, remove excess rubber cement around the edges of the board.

6. Whenever you mark instructions on the overlay, place a sheet of heavy paper between the photograph and the overlay in order not to damage the surface of the print.

Retouching Photographs

Although it's ideal for the photograph to be exactly suited to the job at hand, there are times when some doctoring may be necessary. Unwanted details, weak passages, or imperfections in the photograph can be remedied by means of retouching. If these modifications are extensive, it's advisable to send the photograph to a commercial retouching studio capable of performing this specialized function. If, however, the changes are minor, you'd be wise to develop certain skills in retouching.

Specks of dirt, small blemishes, and minor crease marks can be concealed by *spotting* with "retouching grays" available at photo or art supply stores. These paints are mixed to the value of gray in the photograph and applied with a brush. Retouching more extensive passages requires the use of an airbrush. This instrument sprays paint or dye with compressed air. Using a good airbrush, the experienced artist can achieve meticulously fine work, as well as even spraying of large areas. The color, values, and textures must be matched exactly to those on the print itself. Good retouching is never obvious in the reproduction, but the practice of retouching should not be overused, because it can produce an artificial, almost plastic appearance in the art.

Scaling Art

The art you hold in your hands—the original photograph, transparency, or line art—will probably not be the size you need in your layout. The art must be enlarged or reduced to fit, a process of *scaling* for reproduction by which you indicate to the photostat house or to the printer exactly what size and proportion you want the art to be.

Proportional Scaling

Proportional scaling means changing the size of the original without changing the ratio of the dimensions. For example, if an 8″ × 10″ photograph is reduced by half, both dimensions will reduce in the same proportion, resulting in a 4″ × 5″ image. It is important to recognize that the *entire* image—not simply the height or the width—will change in proportion as you enlarge or reduce.

The Scaling Wheel

Not all dimensions are so neatly calculated as the simple example of 8″ × 10″ to 4″ × 5″ noted above. The scaling wheel, or proportional scale, is a device designed to calculate the percentage of enlargement or reduction and to enable you to determine the dimensions of all sides of the final result. Other instruments can also be used to perform this function—slide rules, proportion calculators, proportional dividers, and so forth—but none is as simple and more convenient than the scaling wheel. Made of flexible plastic, the scaling wheel is inexpensive, simple to use, and easily stored.

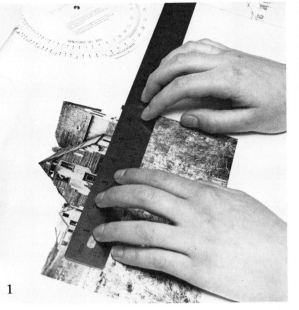

1

2

1. First measure the width of the image area of the original photograph. The dimension here is 5⅞″.

2. Next measure the width of the art as you intend it to appear on the layout. Here the dimension is 7″.

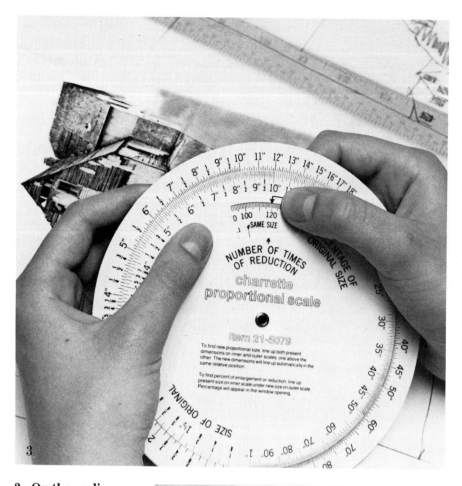

First measure one side—say, the width—of the original art and then measure the width of the image area indicated in the layout. As an example, let's say the width of the original measures 5⅞" and the width of the art in the layout measures 7". Match these numbers on the scaling wheel. Rotate the inner wheel so that 5⅞" lines up with 7" on the outer rim.

While you hold the wheel with these numbers aligned, measure the height of the original art and locate that number (6½") on the outer rim. That dimension automatically aligns with the measurement of the height as it will be in the reproduction. In the window of the wheel you'll find the percentage by which the original art must be enlarged—119%.

3. On the scaling wheel, rotate the dials and line up the width of the original art (5⅞") on the inner wheel with the width of the layout (7") on the outer rim.

4. While you're holding the wheel with the dimensions lined up, measure the height of the original art (6½") and locate that number on the inner rim. The number on the outer rim that lines up with this tells you the height of the image in the layout.

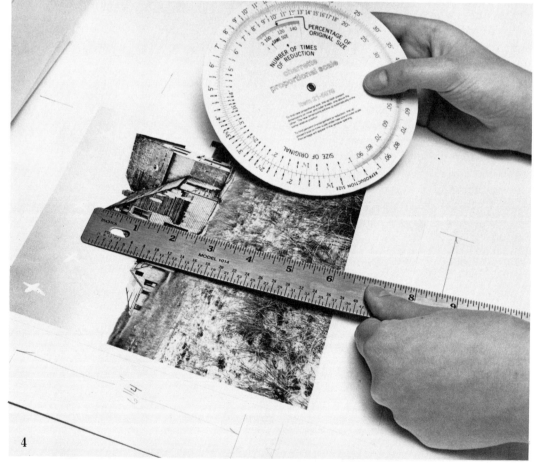

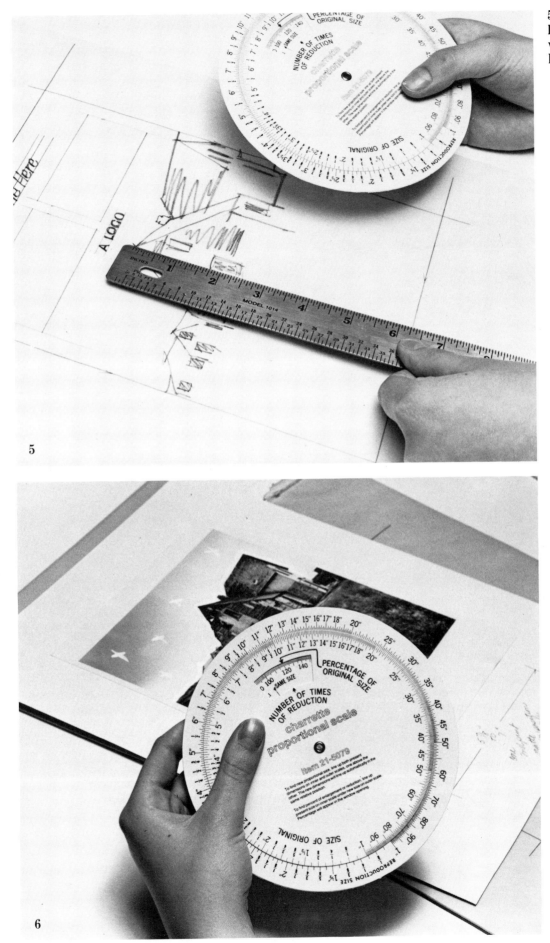

5. Then measure the height of the art as it will appear in the layout.

6. In the window of the wheel you can see what percentage of enlargement or reduction is called for. In our example, the original art should be enlarged 119%.

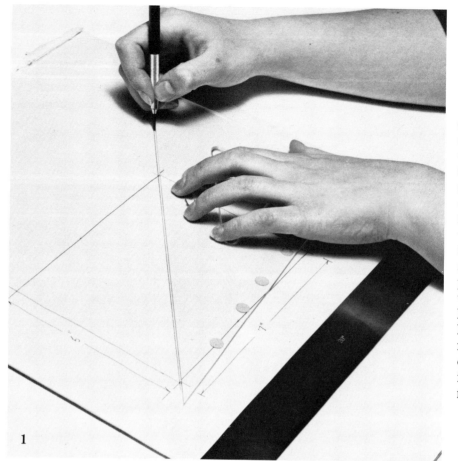

1

Diagonal-Line Scaling

To visualize the increased or decreased dimensions of the image on the layout, a convenient method of proportional scaling requires a simple geometric trick called *diagonal-line scaling*. Try this example. Draw a rectangle with the dimensions of the original art, say, 5″ × 7″. Draw a line, using the straightedge, through two diagonal corners, and continue this line further. Let's say that you want the width of the final image to measure 8¼″. Extend the base of the rectangle to measure 8¼″ and draw a perpendicular line at this point to where it intersects with the diagonal line just drawn. This represents the height of the final image. Any size rectangle drawn on the same diagonal, from either corner, will be in proportion to the original rectangle.

DIAGONAL-LINE SCALING

1. To enlarge a photograph using diagonal-line scaling, first draw a diagonal line through opposing corners of the rectangle representing the art and extend it on the upper right-hand corner well beyond the rectangle. The rectangle measures 5″ × 7″ in this example.

2. Extend the base-line of the art to 8¼″ and draw a perpendicular line from this line to the point where it intersects the diagonal line just drawn.

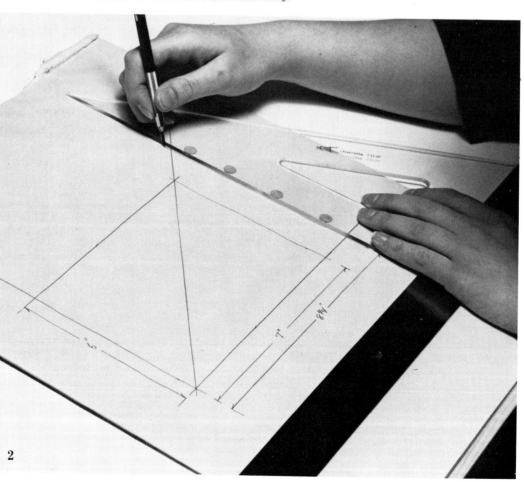

2

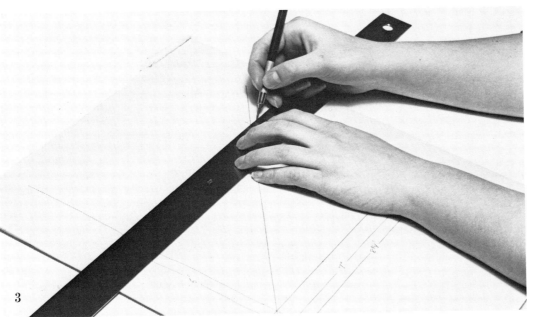

3. From this point draw a horizontal line 8¼″ long.

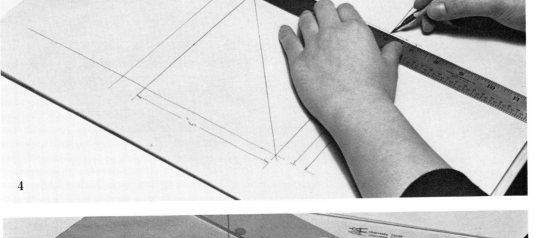

4. With a ruler you can determine the new size of the rectangle.

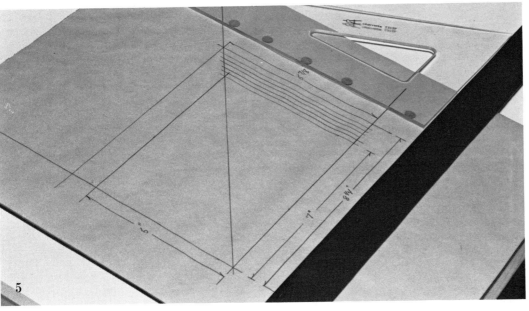

5. Any size rectangle drawn on the same diagonal will be in proportion to the original rectangle.

CROPPING ART

1. Cropping frames —two right angles cut from illustration board—provide an excellent means of visualizing what section of the art to use in the final layout.

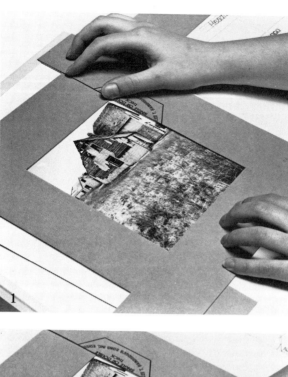

2. With the cropping frames lined up in the desired position, lightly indicate the crop marks by drawing a line at each corner in the margin of the mounted photograph. Here the base line is indicated.

3. The top of the photograph is marked with a horizontal line.

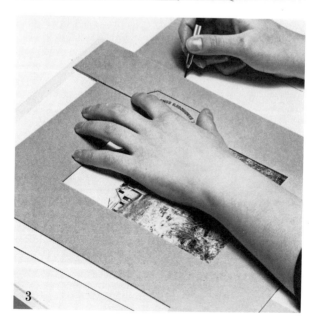

4. The width of the photograph is marked with a vertical line.

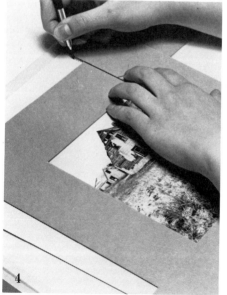

Cropping

Unless the art fits the layout perfectly or unless it's critical to use the entire image, chances are you'll only want to use a section of the photograph. *Cropping* the original, as this process is called, doesn't mean cutting up the art with a pair of scissors. It means marking the section of the original art that is to be used. Although cropping may be done mechanically by the printer, you must determine exactly what portion of the art you will use and to what scale.

Cropping frames are a great help in the first step of determining which section you will use. Cut two right angles of illustration board and place them on the art in such a way that you create a window. Shift the two pieces around until you have a clear idea of the portion you would like for the layout. In the margin of the art that lines up with the inside of the cropping frame, lightly make *crop marks*, the points that indicate the area designated for the final reproduction. Draw these marks at all four corners. If you are marking on the border of the photo itself, use a grease pencil. If you mark the board on which the photo is mounted, use a ruling pen.

Cropping to Scale

Now you know which section of the art you intend to reproduce and you know you may have to alter the proportions of the original. How do you know if the size of the cropped image will fit the layout as you planned it?

Place a piece of tracing tissue over the original photograph and draw a rectangle indicating that part of the art you want to use. Draw a diagonal line through the corners of this rectangle and proceed as before to determine if the cropped image will enlarge or reduce proportionately to fit the layout. It doesn't always work out precisely as you intended. You may have to adjust the size in the layout. More likely — because the layout size has probably been fixed already — you may have to include more or less of the image than you had originally intended to make it fit the proportions needed for the layout. With the width established, we find the true depth of the art by using the diagonal. Any adjustments in cropping should be made at this time.

After you've established that the cropped image will fit the designated space, indicate the crop marks clearly to provide guidelines for the printer.

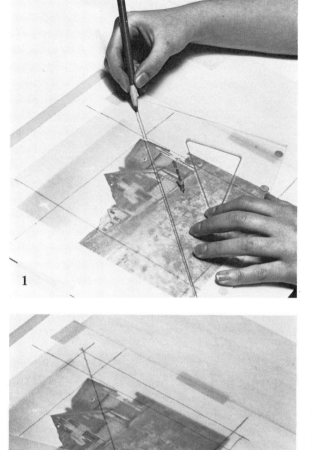

1

3

4

1. The diagonal-line-scaling method enables you to see if your preferred cropping will actually fit the dimension planned in the layout. Tape tracing tissue over the photograph. Following your crop marks with a soft grease pencil, draw a rectangle and then a diagonal line through two corners.

2. Measure the height of the art indicated in the layout—6½″ here.

3. Mark off the 6½″ dimension on the diagonal-line scale over the original art. For a height of 6½″—which is critical to this layout—more of the photograph must be cropped. The tracing paper and diagonal-line scale will help you visualize just where to crop the photograph to fit the layout. Indicate the new crop marks on the mounted photograph and scratch out the first ones.

4. If the 5⅞″ width of the photo is enlarged to 7″ (the width of the image in the layout), the height of the photo will fit the layout as planned. Now you know precisely where to place the crop marks for the printer.

Photostats

A *photostat* is a simply produced photographic print made directly on paper with a paper (not film) negative or without any intermediate negative at all. The latter is called a *direct positive photostat* (DP) or a *photomechanical transfer* (PMT) and is a less expensive method of producing stats, recommended when a negative is not needed. Their simplicity of production means that photostats can be obtained rapidly and at a relatively low cost. Photostats are normally ordered from a firm that specializes in serving the graphic arts.

In photostat parlance, the terms "positive" and "negative" have special meanings. A *positive* repro-

duces the art as it appears to you; a *negative* reverses the blacks and whites. There may be times when you will want to use the negative for copy rather than the positive. For example, if you have art that is black line on a white background and you want to reverse that relationship, request a negative stat and you will receive your art with white line on a black background. There may also be times when the original art itself appears to be a negative. To avoid confusion in your instructions to the stat house in this instance, request a first print if you want the reverse of your art and request a second print if you want the art as it now appears.

Photostats may be produced in several forms. For instance, a photostat may be *flopped* or printed with the image facing the opposite direction, at your request.

Photostats may be glossy or matte in finish. The glossy stat prints white or black only, with no intermediate grays, and is preferable when line copy or reproducible art is desired. Depending on the nature of the art and the amount of enlargement or reduction, a glossy stat can function as original line art, pasted directly into a mechanical in the correct size and position. (If the original line art is very delicate, it may not reproduce well in a stat, particularly if the enlargement or reduction is extreme. In such an event, the printer should shoot directly from the original line art.)

A matte stat is used for indicating halftones, providing a relatively inaccurate idea of the intermediate tones in the original art. Matte stats are not used for original art: they are used to show size and position only, and they are prepared for the printer as described a bit later.

Finally, it is possible to order *color* photostats from some houses. Made of a paper negative, these stats provide a rough color guide. So-called *C-prints* (made from a film negative) provide a better quality image for comps and presentations.

Positive line stat.

Negative line stat.

Flopped line stat.

Ordering Photostats

After you've determined what you need in the layout, you must communicate your intentions to the photostat house so they will enlarge or reduce the original art to the correct size. There are several methods of marking instructions; the one you use depends on what the photostat house prefers. You can indicate the size with the dimensions desired in inches or by the percentage of enlargement or reduction. If the stat is the *same size* as the original art, simply write *s/s* or *s.s.*.

Remember to take into account the cropping: measure the cropped area only. For example, you may have an 8″ × 10″ image, but you intend to use only a 3″ × 5″ section of it in the layout. Take your dimensions from the 3″ × 5″ section, establishing the percentage of enlargement or reduction from that. If the percentage of enlargement is fairly great, indicate on an overlay how much of the original art you want photostated. This will avoid the cost and waste of an extra-large photostat.

Bear in mind that if you have *many* pieces of art, you can save expense *ganging up* the art— by scaling several pictures at the same percentage of enlargement or reduction (at the same *focus*). If possible, cement these images to a single board and have a single photostat made of the entire board. Ganging up will represent savings.

When you send out the art for photostats, write instructions clearly in the margin of the original art: indicate the size, type of stat (glossy or matte), and the type of image (positive, negative, first or second print, flopped). If more than one piece of art is being used in your layouts, it's advisable to indicate a key number—1, 2, 3, etc., or whatever keying system you prefer—in the margin of the original art, or on a tag attached to the art, and in the layout. You may use these key numbers for the captions as well, so that you have a system for matching all elements pertaining to the images in the layout.

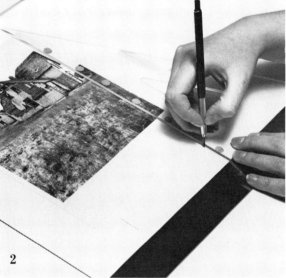

1

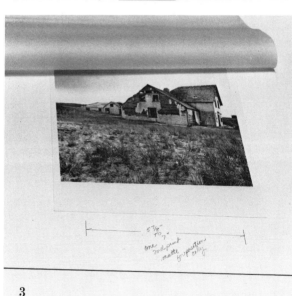

2

3

1. **To prepare art for photostats, first determine where you will crop and to what size.**

2. **Indicate crop marks in the margin of the art.**

3. **Mark the art with the percentage of enlargement or reduction, or mark it with the actual and desired dimensions, as shown here: 5⅞″ to 7″. Indicate the type of stat you want—first or second print, matte or glossy—and make a note that it is for position only.**

Preparing Line Art for the Printer

Line art should be prepared on a clean, white surface. Lines should be dense and clean. Marks that are gray—less than 50 percent black —won't register on the plate-maker's film, and lines that are too fine may disappear or break up during the platemaking process. Art prepared for line reproduction can be done in red, since the camera photographs red as black, but colors such as green and blue are not acceptable because the camera registers them as gray. Lines that are too close together may fill in. Remove or lighten any marks on the art itself—guidelines, for example—that you do not intend for reproduction. Finally, remove any dirt marks, rubber cement, or eraser particles from the art because they may register in the photograph.

It's common practice to work from original line art that is slightly larger than the size intended for the printed piece, because reduction tends to conceal the imperfections in the drawing. Bear in mind, however, that in reduction the lines become thinner; and with enlargement, lines tend to break apart or appear ragged. If you're reproducing several like items in line, it's advisable to scale them in the same proportion so that there is a consistency of line in each drawing. A printed page with drawings of different line thicknesses can be ugly and disorganized.

Another form of line art is the velox, described in the previous chapter. To order a velox, scale the photograph to the desired size, specify the appropriate screen, and send it to a graphics studio that specializes in art preparation. When the desired velox is returned to you, handle it as you would line copy of the same size. The lines or dots should be clean and sufficiently spaced. Because it is line copy, you can draw on it directly with opaque white or black ink to alter the art. Several veloxes can also be combined for a special effect.

Preparing Continuous Tone Art

Halftone reproduction tends to gray the tones, reducing the contrast between black and white. To counteract this tendency, photographs and artwork designed for halftone reproduction should be somewhat exaggerated in contrast, although not so excessively that details are lost in the art.

All the information about the photograph—crop marks, identification, credits, kind of halftone desired (square, silhouette, dropout, vignette, combination line/halftone) —should be marked on the face of the art, preferably in the margins on the board. If you want to write directly on the photographic surface itself, use a grease pencil—it's relatively soft and won't damage the emulsion. Best of all, the marks from a grease pencil can be removed with thinner and a facial tissue. Exercise caution here: some staining may occur and too much rubbing may mar the surface.

Now prepare the mechanical for the printer, indicating square halftones in one of four ways. Any one of these methods can be used, depending on the number of halftones on a page, the accepted practices of your art studio, or the conventional practices of the particular printer. Consult with your printer to see which system is preferred.

1. Square off a photostat of the continuous tone art at the exact size and cropping desired and paste it on the mechanical in precisely the position desired for reproduction. On the surface of the stat write "for position only" so that it cannot be confused with the original art itself.

2. With a t-square and triangle, draw a rectangle in red ink on the mechanical in the size and position desired for the halftone. (These are called *holding lines*.) Cut a ragged edge around the four sides of the photostat and cement it on the mechanical within the holding lines. Write "for position only" on the photostat.

3. First lightly pencil the outline of the halftone on the mechanical. Then place a sheet of masking film—a red dull-finished, transparent-plastic, pressure-sensitive film available in sheets from art supply stores—over the lines. Cut the film with a knife (using your straightedge as a guide), and burnish the film onto the board to leave a sharp red rectangle. (The red photographs the same as black on the printer's film negative, providing him with a precise guide for stripping in the halftone.)

4. Cut a *window* (the shape that follows the contour of the art as it appears in the reproduction) from a sheet of masking film and attach it to an overlay placed over the mechanical. (This method is used most commonly as a guide for stripping if there are several halftones on the same page.)

To indicate a silhouette halftone, follow any of the same procedures as for square halftones, except indicate an outline by trimming the photostat or the masking film according to the approximate silhouette you want.

These methods are all commonly used, and will vary only according to the practices of the individual printer. Always check in advance to see which method is preferred. By adapting your practices to the printer's requirements, you'll save confusion and—not to be overlooked—extra costs.

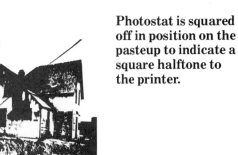

Photostat is squared off in position on the pasteup to indicate a square halftone to the printer.

Photostat is in position on the pasteup with red holding lines to indicate a square halftone.

Square halftone is indicated with masking film placed on the mechanical.

Square halftone is indicated with masking film on an overlay over the original art.

SILHOUETTING WITH MASKING FILM

1. To silhouette with masking film, first lay a sheet of the plastic film over the art. Tape the film to the board to make an overlay.

2. Trace the outline of the art with a cutting knife. Cut into the surface of the film without penetrating the polyester sheet to which the film is adhered.

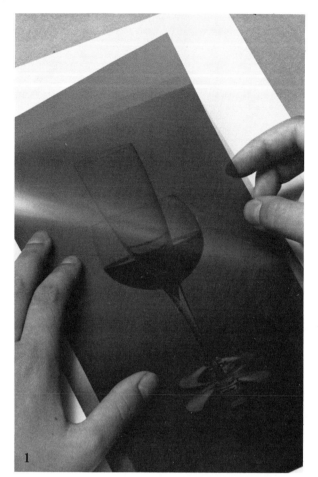

1

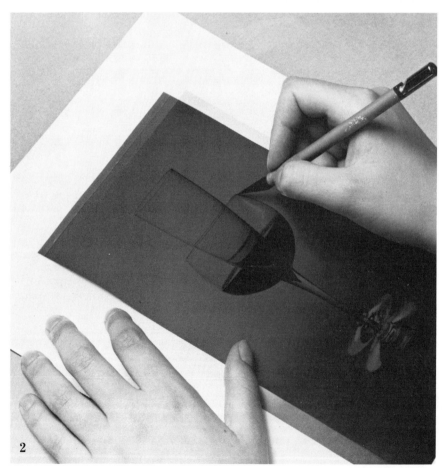

2

Silhouetting

There may be times when you'll be required to silhouette the art in the studio, particularly when the contour of the art requires close attention. Always leave as little choice as possible to the printer. If there are subtle decisions to be made, you must assume that responsibility in the studio. The results will pay off in quality and in costs.

There are two accepted methods of silhouetting art: with masking film or with white paint. The method you use is generally determined by the requirements established by the printer. Check this out in advance. Regardless of the method used, work only on mounted art, because silhouetting can cause buckling.

Silhouetting with Masking Film

Tape a sheet of masking film over the art to be silhouetted. Trace the outline you want on the film with the edge of a sharp knife. Peel away the unwanted portion of the masking film, exposing the clear overlay. The printer's engraver will use this mask as the final guide, so be certain the cut is precise. If you happen to cut too much away from the mask in one area, rather than redo the whole mask, you can retouch by applying a masking ink to the polyester, which dries to form a film like the original. This liquid, available at art supply stores, is applied with a brush and dries rapidly after application.

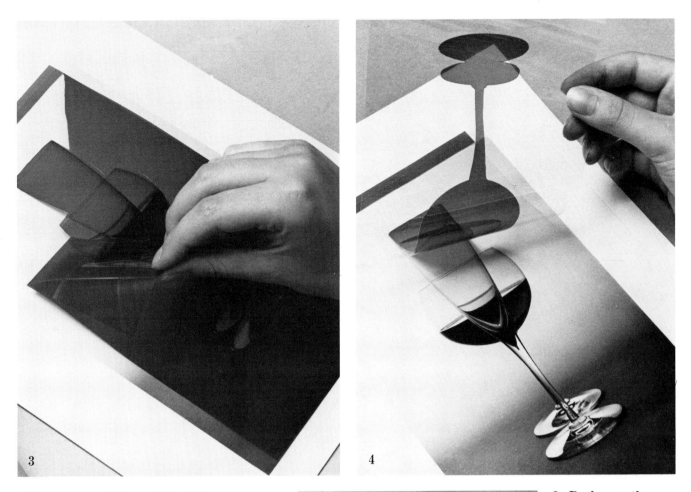

3. Peel away the unwanted film.

4. What remains is an acetate overlay with a mask indicating the silhouette.

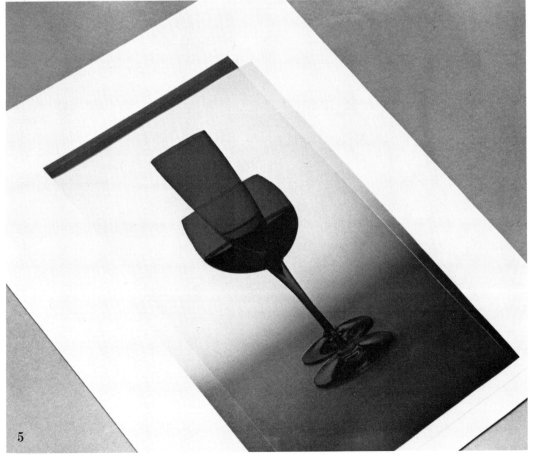

5. Here is the mask in position—the guide to be followed by the printer.

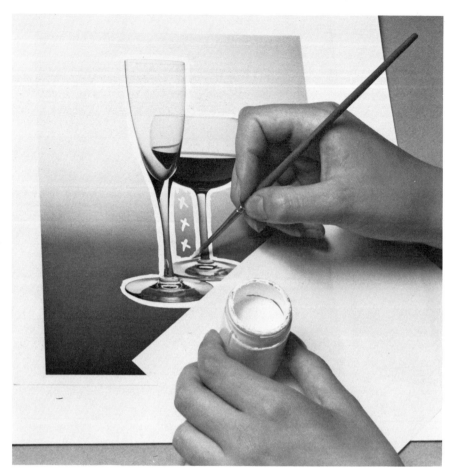

Silhouetting with White Paint

Although some printers prefer masking film for silhouettes, the painted silhouette has distinct advantages. Chances are that you can obtain a more accurate contour by painting around the edges — particularly if the contour is varied — than you would by cutting into film with a knife.

With this method, use a fine brush and white poster paint mixed to the consistency of heavy cream. Outline the entire shape in a thin white line. This line must be accurately drawn because it will be the actual outline of the silhouetted reproduction itself. Enlarge the band of white to about ⅛". If there are passages *within* the art that should be silhouetted out — such as background areas that may be surrounded by the image itself — simply mark these with opaque white crosses.

Cutting a Mask

Using the method of silhouetting with white paint, you may find it advisable to also place a mask over the art. Cutting a mask for this purpose is a technique worth knowing. After the paint has dried thoroughly, tape a sheet of tracing paper over the art and trace an outline along the center of your white silhouette band with a sharp pencil. Remove the tracing paper and cement it to a sheet of white bond paper. Now trace the pencil outline on the paper with a sharp knife, cutting through both the tracing tissue and the white bond. Lift away the cut-out, peel away the tissue from the bond, and remove the excess dried rubber cement. Now take the bond and position this as a mask over the art, so that the contours of the mask fall at the center of the white band painted on the art. With the mask placed in this position, hinge it at the top of the board with masking tape.

SILHOUETTING WITH WHITE PAINT

To silhouette with paint, use a fine brush and trace the contour of the art. (First treat the surface of the glossy so that the paint will lay on well by moistening a piece of cotton with your saliva and wiping it over the area.) Then enlarge the fine line to a thickness of about ⅛". Paint crosses in the areas of the image you want the printer to eliminate.

CUTTING A MASK

1. Tape tracing tissue over the art, and with a sharp pencil trace a line along the center of the white band painted on the art.

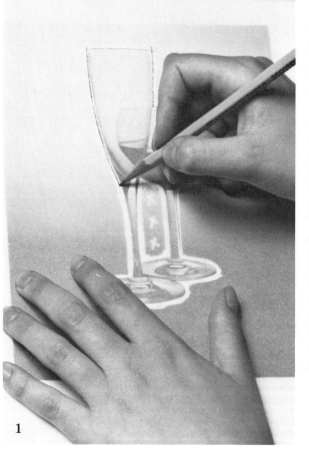

1

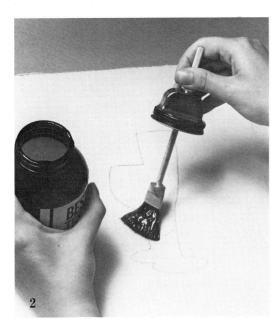

2. Remove the tissue, turn it over, and apply cement to the back of the paper.

3. Turn over the tissue and lay it on a sheet of white bond paper. With the edge of the triangle press it flat to ensure firm contact between the two papers.

4. With a sharp knife, carefully trace the pencil line, cutting through both the tissue and the bond.

5. Lift away the cut-out and throw it away.

6. Peel away the tissue from the bond.

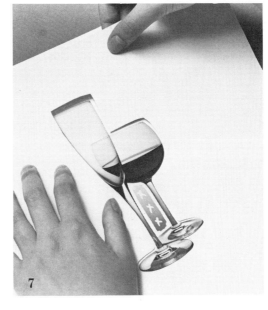

7. Position the white bond so that the cut-out falls at the center of the white line painted on the art. Trim off any excess white bond.

6: WORKING WITH TYPE

Type specimen books are available from typesetters. A *spec book*, as it's called, is a catalog of the faces available from that compositor, providing appropriate technical information about each face.

By now you have acquired knowledge about two major aspects of preparing art for reproduction: how to create inked lines and how to handle artwork. The third essential ingredient in the pasteup is the type itself. For a comprehensive understanding of type and its application, consult books devoted exclusively to the subject. Here we'll focus specifically on the studio procedures that will concern your work in preparing mechanicals.

Spec Books

You'll need a type specimen book for working with type. *Spec books* (as they are called) are supplied by typographers, providing a catalog of the faces available from that source. In a type spec book you'll be able to identify the name of the face desired, how the face appears in different applications, and its technical characteristics—the number of characters that will fit within a certain width. For layout purposes, these samples may be photocopied and placed in position on a dummy.

When ordering type, the book is your guide for nomenclature. These are only a few of the functions that make the spec book indispensable.

Copyfitting

When the designer is given the manuscript, two choices must be made: the *style* of the typeface and the *size*. Both decisions will be determined by the requirements of the layout. You may have a special preference for a certain face in a certain size, but unless it fits within the required area, the preference is of little value. In designing the layout, it's a good practice to determine at the outset how much space to allow for type. Without deciding the specific face, you should have some rough idea about how *much* space will be required.

Once you have the manuscript and a rough layout, it's time to see if the copy will fit. The process of converting typewritten copy into type is called *copyfitting*. It's a two-step process:

1. *Character counting:* calculating the amount of typewritten copy you have.

2. *Casting off:* translating the number of characters (or amount of typewritten copy) into a specific typeface in the required size, spacing, and width required for the layout.

Character Counting

Every letter and space must be counted—every unit in a line—to establish the total amount of copy.

`The German-born craftsman, Michael Thonet, had invented`

Comparison of elite, pica, and proportional typewriters.

`The German-born craftsman, Michael Thonet, had invented a process`

`The German-born craftsman, Michael Thonet, had invented a process`

To count, first establish how the copy was prepared. The manuscript was probably typewritten with a pica or elite typewriter. The pica has a larger face, printing out 10 characters per inch; the smaller elite prints 12 characters per inch. There are also typewriters that have proportional spacing, each letter spaced individually according to its specific shape—the m consuming more space than the i, for example. With proportionally spaced typewriters, accurate character counting is more difficult. The best you can do is count each letter, punctuation mark, and space in 3 or 4 inches and arrive at an average per line character count. Averaging is not necessarily exact and you may be off by 10 percent (higher or lower). With large bodies of copy this is significant. Always calculate on the high side, therefore, to play it safe.

If you count each letter, punctuation mark, and space, as one character, how many characters are there in a single line of your copy? Rather than count each item individually, measure the number of inches on that line and multiply by 10 or 12, depending on the typewriter used for the manuscript.

This is easy enough with a single line. Now let's extend that to a paragraph and then to a full page. Lay the ruler across the copy and find the length of an average line in

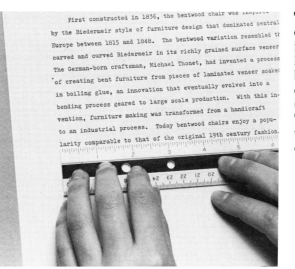

First constructed in 1836, the bentwood chair was inspired by the Biedermeir style of furniture design that dominated central Europe between 1815 and 1848. The bentwood variation resembled the carved and curved Biedermeir in its richly grained surface veneer. The German-born craftsman, Michael Thonet, had invented a process of creating bent furniture from pieces of laminated veneer soaked in boiling glue, an innovation that eventually evolved into a bending process geared to large scale production. With this invention, furniture making was transformed from a handicraft to an industrial process. Today bentwood chairs enjoy a popularity comparable to that of the original 19th century fashion.

To count characters on a page, take a typical line length (6″ here) and multiply it by the number of characters per inch (10, in this case). Then multiply this by the number of lines on the page.

inches (usually halfway between the longest and shortest lines). Lightly draw a vertical rule with a pencil, making a right-hand margin. The average length of line with pica typewritten copy is 60 characters. Multiply this by the number of lines—16 in the example shown. Add up all the extra characters to the right of the vertical line. Add this to the first number. Add up the number of empty spaces to the left of the vertical line and subtract this from the total. The result is 1,028 in the example shown. The process of counting a paragraph is the same as that for counting a page or several pages of copy.

Casting Off

Now the quantity of manuscript copy must be translated into a specific typeface to fit within a specific area on the page.

The units of measurement in type are calculated in picas and points rather than inches or centimeters (also units in computer type). Your ruler should provide both sets of calculations—a pica measure along one edge and inches along another—with 12 points = 1 pica and 6 picas = 1 inch. Using this measurement, calculate the size of the type block in picas. The space measured from left to right is 13 picas wide. This is known as the *measure*. How many characters of 9 point Helvetica will fit into a 13-pica measure? Take a type specification book and look up Helvetica, 9 point. You will find that 2.6 characters of Helvetica will fit into 1 pica. For the measure you want, therefore, multipy 2.6 by 13 picas to establish how many characters per line you will have in 9 point Helvetica.

Measure the area you would like to fill in the layout. Let's say it is 13 × 37 picas. How do we fit 1,028 characters into that block? By trial and error. Let's try, for example, using 9 point Helvetica.

How many lines will be required if the copy is set in 9 point Helvetica? Your manuscript indicates 1,028 characters for that space. Divide 33.8 into that number and you get 31 lines. In other words, set in 9 point Helvetica the copy will be 31 lines deep. Now measure the area and you find that the depth of the type area is significantly larger than 31 lines. What you haven't allowed for, however, is the space between the lines, or the *leading* (pronounced "ledding"), as it's called. In other words, the 9 point Helvetica

Measure the area of copy to be filled in your layout.

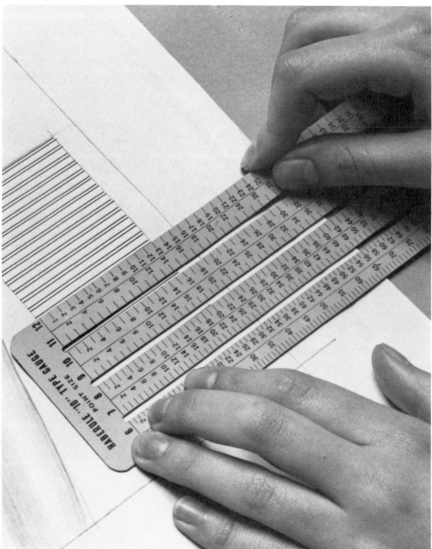

In type, you'll work with a measure of picas and points—6 picas equal 1″; 12 points equal 1 pica.

has only been calculated to be *set solid*, with no space between the lines. Once we add the space, the type should fit the area nicely and be far more readable.

Leading is measured in points ranging from 1 to 12 (or more) to provide the vertical spacing you require. The amount of spacing between the lines is determined by factors other than simple design considerations, and we recommend you study this subject further in a book devoted to typography (see the Selected Bibliography in the back of the book). For our purposes, we are concerned with leading only as it affects the area of space you're laying out.

If we insert 3 points of lead between each line, we know that every line will occupy 12 points of depth — 9 for the type and 3 for the space between the lines — which, when multiplied by the number of lines of type, comes to 372 points. Now, divide by 12 and you have the total number of picas of depth — or 31. (Bear in mind what we said earlier: copy may run as much as 10 percent longer or shorter than anticipated, simply because there may be more *i*s or *w*s — more narrow or wider characters — in any given copy. When you're planning a layout, always use an average.)

We happened to arrive at this calculation rather simply because our type plus lead equaled 12 points. or 1 pica. Not all calculations can be so quickly resolved. It may be that the point size of the type must be increased or decreased or that more space should be added or taken away between the lines. It may be that the copy is simply too long or too short for your design concept and that you may have to rework the idea altogether to accommodate the actual copy you have. Or it might work out that you have the copy rewritten to fit your layout instead. Any of these factors may influence the final design. It can also happen that you simply tell the writer how many characters you need for a given space and the writer provides them.

Bentwood: a classic design that is forever contemporary. The curves and loops that have graced interiors for over one hundred years continue to be among the most popular chairs today. Lightweight yet sturdy, the bentwood chair readily adapts to any environment: to the home, the office, a boulevard cafe. Always in fashion and always in good taste.

First constructed in 1836, the bentwood chair was inspired by the Biedermeir style of furniture design that dominated central Europe between 1815 and 1848. The bentwood variation resembled the carved and curved Biedermeir in its richly grained surface veneer. The German-born craftsman, Michael Thonet, had invented a process of creating bent furniture from pieces of laminated veneer soaked in boiling glue, an innovation that eventually evolved into a bending process geared to large scale production. With this invention, furniture making was transformed from a handicraft to an industrial process. Today bentwood chairs enjoy a popularity comparable to that of the original 19th century fashion.

Here is 9 point copy set solid (with no leading).

Bentwood: a classic design that is forever contemporary. The curves and loops that have graced interiors for over one hundred years continue to be among the most popular chairs today. Lightweight yet sturdy, the bentwood chair readily adapts to any environment: to the home, the office, a boulevard cafe. Always in fashion and always in good taste.

First constructed in 1836, the bentwood chair was inspired by the Biedermeir style of furniture design that dominated central Europe between 1815 and 1848. The bentwood variation resembled the carved and curved Biedermeir in its richly grained surface veneer. The German-born craftsman, Michael Thonet, had invented a process of creating bent furniture from pieces of laminated veneer soaked in boiling glue, an innovation that eventually evolved into a bending process geared to large scale production. With this invention, furniture making was transformed from a handicraft to an industrial process. Today bentwood chairs enjoy a popularity comparable to that of the original 19th century fashion.

Three points of leading were inserted to increase the depth.

[BENTWOOD] [HELVETICA MEDIUM ALL CAPS ½" (TIGHT LETTER SPACE)

[Forever Contemporary] → 20 pt HELVETICA LIGHT U+LC

Bentwood: a classic design that is forever contemporary. The
curves and loops that have graced interiors for over one hundred
years continue to be among the most popular chairs today. Light-
weight yet sturdy, the bentwood chair readily adapts to any
environment: to the home, the office, a boulevard cafe. Always
in fashion and always in good taste.

 HELVETICA LIGHT 9 pt / 12

 ×13 ② 9' INDENT

First constructed in 1836, the bentwood chair was inspired
by the Biedermeir style of furniture design that dominated central
Europe between 1815 and 1848. The bentwood variation resembled the
carved and curved Biedermeir in its richly grained surface veneer.
The German-born craftsman, Michael Thonet, had invented a process
of creating bent furniture from pieces of laminated veneer soaked
in boiling glue, an innovation that eventually evolved into a
bending process geared to large scale production. With this in-
vention, furniture making was transformed from a handicraft
to an industrial process. Today bentwood chairs enjoy a popu-
larity comparable to that of the original 19th century fashion.

FLUSH LEFT, RAG RT

[LOGOTYPE] HELVETICA OUTLINE ALL CAPS ⅜" TIGHT LETTERSPACE

The manuscript is marked for type and released to the typesetter.

Marking Copy for Type

After your client has approved the design and typographic treatment indicated in the layout, the type is ready to be set by a typesetter, or compositor. Your instructions to the typesetter must be legibly written in clear language. Errors in typesetting that originate from the studio are costly to correct, and will reflect poorly on your skills. Avoid this by taking the necessary time to prepare the copy properly for the compositor.

The manuscript should be neatly typed and double-spaced on 8½″ × 11″ paper. Your instructions should be grouped in the upper left-hand margin of the page and marked in a colored pencil or pen to distinguish it from the manuscript itself. Your instructions indicate the desired typeface, point size, leading, and measure. Using our example, you would write 9 point Helvetica on 3 points of leading by a 13-pica measure as:

9/12 Helvetica × 13

The instructions should also include how the lines should be set: flush left and right (justified), flush left and ragged right, flush right and ragged left, or centered.

Other instructions may specify styling, such as capital letters (caps), capital letters combined with small letters (upper and lowercase, written u/lc), small caps, boldface, italics, and so forth. Consult a book on typography for more specific instructions and for the industry symbols and abbreviations commonly used to indicate these variations in type (see Selected Bibliography).

Type Proofs

The typesetter will return the manuscript and the copy in proof form for layout and proofreading purposes. These *galley proofs* may be printed on newsprint paper in long narrow sheets, or they may be photocopies of the type. In any case, they are not final copy. While one set of proofs is being read for errors in copy (*proofreading*), you must check your set against the layout. Does it fit your layout as you planned? Are the type style and measure correct? Is the type properly aligned? If there are inconsistencies, check to see if the error lies with your instructions (in which case their correction should be noted as an AA, or *author's alteration*, and corrected at the client's cost) or if the error lies with the typesetter (in which case the error should be noted as a PE, or *printer's error*, and corrected at the compositor's expense).

If the copy appears to be as you planned it, cut up the proofs and lay them in place on your layout. Since this is not the final mechanical, you can adhere the copy informally with transparent tape.

Now is the time to lay out the pictures as well. The art should be scaled — marked for the correct enlargement or reduction — and sent out for photostats. These photostats should be the size desired for the layout so that you can place them in position with the type.

Before returning the type for final proofs, check to see if there have been any editorial changes that might affect your layout. Has copy been cut, added, or rearranged?

Finally, the master set of proofs, containing all changes, is sent to the typesetter. What is returned — with corrections made — is the final type proof: the reproduction proof (or *repro*, as it is called), which is used in the mechanical. The repro should be checked against the galley proofs to be certain that the typesetter made all the changes, but did not create any additional errors in the process.

Bentwood: a classic design that is forever contemporary. The curves and loops that have graced interiors for over one hundred years continue to be among the most popular chairs today. Lightweight yet sturdy, the bentwood chair readily adapts to any environment: to the home, the office, a boulevard cafe. Always in fashion and always in good taste.

First constructed in 1836, the bentwood chair was inspired by the Biedermeir style of furniture design that dominated central Europe between 1815 and 1848. The bentwood variation resembled the carved and curved Biedermeir in its richly grained surface veneer. The German-born craftsman, Michael Thonet, had invented a process of creating bent furniture from pieces of laminated veneer soaked in boiling glue, an innovation that eventually evolved into a bending process geared to large scale production. With this invention, furniture making was transformed from a handicraft to an industrial process. Today bentwood chairs enjoy a popularity comparable to that of the original 19th century fashion.

RESET JUSTIFIED FLUSH LEFT +RT x13 9pt AA

After laying out the proof with photostats in position, the designer has decided to alter the specs. The copy is marked to change from 9/12 flush left, ragged right to 9/9 justified (flush left and right). The change is called an *author's alteration.*

Bentwood: a classic design that is forever contemporary. The curves and loops that have graced interiors for over one hundred years continue to be among the most popular chairs today. Lightweight yet sturdy, the bentwood chair readily adapts to any environment: to the home, the office, a boulevard cafe. Always in fashion and always in good taste.

First constructed in 1836, the bentwood chair was inspired by the Biedermeir style of furniture design that dominated central Europe between 1815 and 1848. The bentwood variation resembled the carved and curved Biedermeir in its richly grained surface veneer. The German-born craftsman, Michael Thonet, had invented a process of creating bent furniture from pieces of laminated veneer soaked in boiling glue, an innovation that eventually evolved into a bending process geared to large scale production. With this invention, furniture making was transformed from a handicraft to an industrial process. Today bentwood chairs enjoy a popularity comparable to that of the original 19th century fashion.

Correct proof.

MAKING A CHISEL POINT

1. To make a chisel point, rub the lead along a sanding block, flattening two sides of the point so that it resembles a screwdriver.

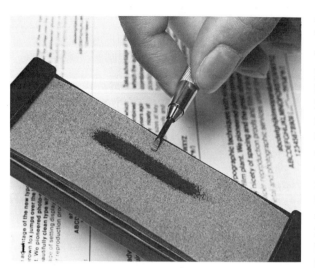

2. Match the chisel point to the x-height of the type you intend to comp. Here the point must be reduced because it is wider than the x-height of this face.

3. To reduce the width of the point, sand the other two sides of the chisel point to the desired width.

4. Now the chisel point matches the x-height of the type.

Indicating Text Type

There may be times when you're expected to make a presentation prior to the mechanical: a sample layout for the client or printer to indicate the type you'll use before it is actually set. Type indication shows the overall appearance and placement of the typeface in the layout; it does not require reproduction of the actual words themselves. One method of indicating type is that you can make photocopies of the selected type in the spec book and lay this in the proper position in the layout.

Another method of indicating type is by making type comprehensives, or *comps*, as they are called. With this procedure you draw the type in pencil to simulate its general appearance without indicating any words whatsoever.

Making a Chisel Point

Type can be simulated effectively with a chisel point pencil, the lead sanded flat on two sides to create a squared-off edge. Match the edge of the blunt pencil point to the height of the midsection (the *x-height*) of the typeface, and sand the two sides of the point to the correct size. Adjust the width of the chisel point with sandpaper until it matches the type size of the typeface.

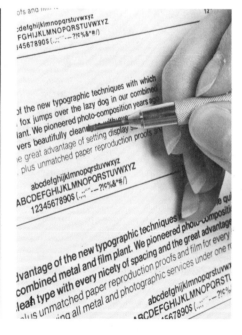

Methods

There are four basic methods of indicating text type, the first—and most popular—is that using the chisel point pencil. Using the t-square and triangle as a guide, lightly mark off the boundaries of the type area in your layout. Then tape the Haberule alongside the paper and place your t-square in line with the appropriate size and leading. With the chisel point held at a right angle to the t-square, draw the first line of type. Slide down the t-square to the next interval and draw the second line with the desired leading. Comp each line this way until you have indicated the entire type area of the layout.

Some artists prefer to indicate text type with pairs of parallel lines. The principle is the same as that of the chisel point comps. The line above indicates the top point (*waist line*) of the x-height, and the line below indicates the bottom point (*base line*).

Another method of indicating type is by the *loop method*. Lightly draw in the waist and base lines of the type as you would with the parallel line method. In freehand, draw loops between the parallel lines that simulate the shapes of letters and indicate the occasional *ascender* (the top stem of the b, h, l, etc.) and the *descender* (the lower stem of the g, j, p, etc.) above and below the guidelines. The loops should be spaced more or less according to word lengths.

Finally, there is the *Greeking method* of indicating type. This is the form most frequently used for very finished comps. Here you imitate the shapes of the letters without creating actual words. These shapes are not joined.

Square up a sheet of paper on the board and, in pencil, lightly rule the boundaries of the block you need. Tape the Haberule alongside the block and line up your t-square to the point size you desire. (Put masking tape over the point sizes you're not using to avoid confusion.) With the chisel point, draw clean, even pencil lines across the block to indicate type, sliding the t-square down in desired intervals between the lines.

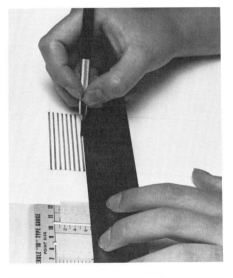

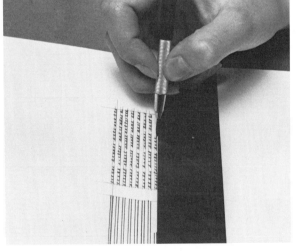

A loop method of indicating type is also used for comps. Drawn in freehand between ruled parallel pencil lines, the loops indicate the x-height and occasional ascenders and descenders.

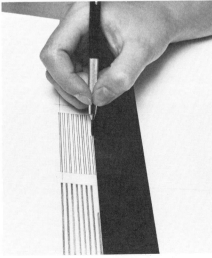

Far left:
Here the same system is used to create a comp with ruled parallel lines. With a sharp pencil or pen, indicate the top and the base of the x-height with clean, parallel strokes.

Greeking is another effective method of comping type. Here you imitate the shapes of letters without creating actual words.

INDICATING DISPLAY TYPE

1. Tracing display type is an effective method of comping. First draw a base line on a sheet of visualizer paper and place this over the appropriate letter shown in a spec book, with the letter properly aligned on the base line. Trace the outline of the letter with a sharp pencil or pen.

1

2. Outline the rest of the letters in the same manner, maintaining consistent spacing between the letters.

2

3. After the letters have been outlined, fill them in with a pen or sharp pencil.

3

Indicating Display Type

Display type — or *headline type* as it is sometimes called — can be indicated with photocopies made from the spec book. Be certain to count the precise number of characters in a sample so that the comp provides an accurate rendition of the length and placement of the actual copy. If capital letters are used, be certain to put these in their proper place.

Comping display type is a specialized skill that many designers develop to an art. Here the comp not only spells out the specific words, but simulates the appearance of the face itself. Briefly, the process is as follows: On a piece of tracing paper, draw a base line on which all the display letters will sit. Turn to the page of the spec book that features the face and size of the display type you want. Place the tracing paper over the first letter in the word and position it so that the letter sits at the left on the base line. Now trace the outline of the letter with a sharp pencil. Place the paper over the next letter and do the same until you have traced all the letters in the headline. Then lightly fill in the spaces between the outlines to make solid letterforms. The tracing paper can then be taped or cemented to the layout in the correct place.

Dry Transfer Type

A great many graphic art aids are available at art supply shops that make it possible for you to indicate display type more mechanically. Produced by several manufacturers, dry transfer alphabets come in a wide variety of styles and sizes. Individual sheets contain the typeface in caps, small letters, and numerals. One form of dry transfer is the self-adhesive sheet. Each letter is cut out with a knife, lifted from the sheet, and positioned on the layout. Another form of transfer lettering is the rub-on type. The characters are printed on a wax-backed, thin acetate film. When the film is placed waxed side down on the layout, thoroughly burnished, and lifted, the letter is transferred from the sheet to the layout. In transferring, be certain the type is aligned and accurately spaced before rubbing. A well-executed line of transfer type can actually serve as camera-ready type copy.

These, then, are the rudimentary methods of working with type. In later chapters you'll learn how to handle the repros for pasteups and how to paste down letters and type in unusual configurations. You will also learn an all-important skill: how to make typographic changes in the mechanical.

1

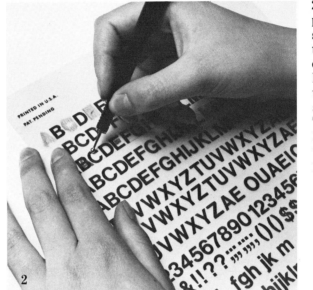

2

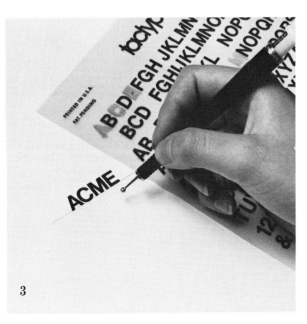

3

APPLYING DRY TRANSFER TYPE

1. Dry transfer type is frequently used to create polished presentations. Trace a base line on a sheet of visualizer paper.

2. Place the appropriate letter from the sheet of transfer type—waxed side down—on the base line just drawn. Rub the entire letter with a good burnisher. This will transfer the letter from the sheet to the visualizer paper.

3. Dry transfer type, properly applied, can actually be used as camera-ready copy.

7: BASIC PASTEUP PROCEDURES

By now you've acquired the skills needed to prepare art for reproduction. Putting these skills together means making what is called a *mechanical*, or *camera-ready copy*. Here you'll combine all the elements—display and text type and art—on a single board, precisely in place, and free of any unwanted marks that the camera might register. We'll start with a simple mechanical for a standard 7″ × 10″ ad, using one block of copy, some display type, and one picture. In the next chapter we'll consider more complex mechanicals.

Tools for the Pasteup

Put all your materials in place before you begin, to avoid the annoyance of interrupting the pasteup process midstream. Be sure you have at least one sharp, single-edged razor blade. Check the consistency of the rubber cement to be certain it's thin enough to flow freely from the brush, and add thinner now if you find it too thick. Place a set of dividers nearby, as well as tweezers, masking tape, t-square, and triangle. For marking, you'll need a ruling pen and ink and a nonreproducible blue pencil.

Pasteup Methods

Copy pasted to the board must lie flat, with no corners curling and no waves or air pockets on the surface. An adhesive that is easy to apply and leaves no visible residue is needed for pasteups. One- or two-coat rubber cement is most effective. Wax can also be used—as we'll describe briefly—but we'll concentrate here on the classic two-coat cement method. In some ways this is the

most difficult, but after mastering two-coat, you'll find all other methods relatively simple. Here is a rundown of the different adhesives.

Wax

In recent years technical improvements have made the use of wax a more feasible method for pasting down art. It is no longer necessary to acquire a costly automatic waxer for smaller jobs. Many artists prefer a small manual, electrically heated waxer. A bar of wax (available at art supply shops) is dropped into the head of a waxer and melts within a few moments. By ironing the waxer along the back of the proof or photostat, you deposit a thin strip of wax that creates a tacky surface. The proof then adheres to the board when it is pressed into place.

To remove copy that has been mounted with wax, slip the corner of a razor blade along the edge of the proof and lift up and away. The proof can be adhered again without applying a new coat of wax as long as the tackiness is not destroyed, which can happen if you remove it too many times.

Waxing is best for mechanicals that need not be stored for a long period of time or won't be subjected to the rigors of shipping or much handling. The brittle nature of dried wax makes these pasteups more fragile and impermanent.

Standard Rubber Cement

Many artists still prefer to use rubber cement as an adhesive because of its qualities of permanence and flexibility. Standard cement is a two-coat rubber cement that can be

applied in any of three methods. *Drymount* is the most permanent. The cement is applied to the backs of both surfaces and each is allowed to dry. The two pieces bond instantly when they come in contact with each other. You can also apply the cement to one side and let it dry, then to the other side, and place the art in position while the second is still wet. This allows you to maneuver the art into position more easily. The third method is to apply the cement to one surface only and then place the art in position while it's still wet. Once in position, the cement spreads to the surface below. Now carefully lift the art one half at a time to allow the cement to dry. When you drop it back into place, it is effectively dry mounted.

After the proof has been adhered to the board, it can still be removed. Lift it from the corner with your single-edged razor. As you lift, squirt thinner under the corner. The cement will loosen almost instantly. After you've removed the proof, be certain to remove all traces of rubber cement with the pickup or any other dirt particles that may have been left behind, unless you wish to reposition the art. In that case simply allow the cement to redry and place the art in the new position. Be sure that the art is not mounted over dirt particles, so unsightly bumps don't appear on the surface.

One-Coat Rubber Cement

Unlike regular cement, only a single coat is required with this stickier substance called *one-coat cement*. The adhesive is applied to one side of the proof or art, allowed to dry, and then placed in position. After it's properly placed, burnish it with a ruler or triangle edge to secure it to the board.

If you want to remove the proof after it's been pasted down, simply lift away a corner from the board with the single-edged razor, gently pulling it free. To avoid tearing, squirt a bit of thinner at the sticking point to loosen it before you try lifting it. The proof can be adhered again without further applications of cement.

One-coat cement is faster than two-coat and results in less clean-up later. It's particularly recommended for adhering fragments of copy, small corrections, or short captions, as described in Chapter 9. It's also ideal for creating layouts and dummies where precision is not required.

However, one-coat cement sticks to *everything*. Using it with skill requires practice and extremely fastidious work habits. Don't let it come in contact with other items in your work area. Clean surfaces of any residue. Be sure the mechanical is free of any excess cement when you file it away because the tacky cement may adhere to other items in the file.

Because of this extreme tackiness, one-coat mechanicals are best attempted only after you have mastered the two-coat method. Caution and control are required when mounting anything as large as $4'' \times 5''$ with one-coat cement. For example, slipsheeting is almost impossible except with a heavily textured watercolor paper such as Beau Brilliant. Likewise, cutting copy that has been cemented with one-coat is awkward, although we do describe a method of making this cutting task easier in Chapter 9. To begin, however, we recommend the use of two-coat cement so that you can focus on mastering your paste-up skills without being distracted by the cement sticking to everything.

A proof can be removed even after it has been cemented. Begin by lifting a corner with a razor blade. As you lift the proof away from the board, squirt cement thinner under the corner behind the proof, peeling it as you go.

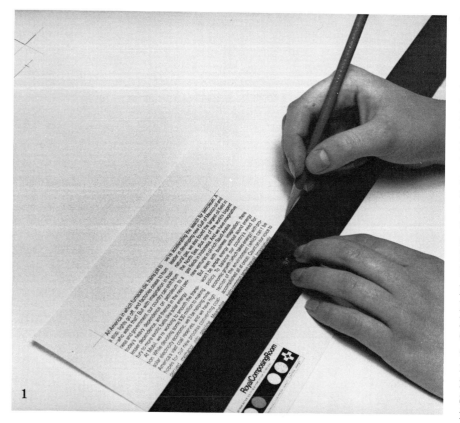

1

Trimming the Copy

First prepare the copy. If the repro is inked—rather than being photographic proof—spray it lightly with so-called *workable fixative* before you handle it further in order to prevent smudging. Mark the copy with nonreproducible blue guidelines for trimming. With your t-square as a guide, mark the lines on all four corners of the copy, touching the tips of the letters with the blue lines. Extend the lines so that they continue about ¼″ beyond the corners. The blue lines should frame the copy blocks and run off the edges of the proof at the four corners. Place the proof face down on a pad of tracing paper and apply cement on the back. (By placing the proof on the pad you can brush over the edges with cement without worrying about depositing excess cement on the surface. Simply dispose of the sheet of tracing paper after cementing. This method is especially efficient for big jobs where many pieces are involved.)

After the copy has dried, turn it over and place it face up on a good quality illustration board on which you'll trim it. (The illustration board is good as a cutting surface because it doesn't flake.) Trim all the proofs first so you can be sure to make square and even edges. Although the camera will not register uneven edges, irregularities may be optically misleading when you try to align the proof on the board. Trimming the copy as the first step is also a more efficient method of preparing the material exactly as you need it so that you can concentrate on the

TRIMMING THE COPY

1. Before trimming, mark off guidelines with nonreproducible blue pencil to indicate where the copy will be trimmed. Draw these guidelines so that they skim the letterforms very slightly.

2. Place the copy face down on a pad of tracing paper and brush on cement from edge to edge.

2

pasteup later, without interrupting the activity to trim copy at that time. Advance trimming also gives you an opportunity to check the squareness of the type proofs.

To trim the copy, make horizontal cuts for each column of type, holding the proof firmly against the board with the t-square to prevent it from slipping. Slice the proof just to the outside of the blue guidelines, without cutting into the lines themselves, except at the extended corners. Turn the board 90° and continue to cut horizontally on all four sides. Place the pieces of trimmed copy, tacked to the board, in an accessible place, so that you can peel the copy away as you need it.

Squaring Up

In the mechanical, you paste up the type and art in position on illustration board, and align, or *square*, them to each other and to the page itself. To begin the mechanical, place on the drawing board a clean sheet of smooth illustration board large enough to permit a margin of at least 3″ around the sides of the to-be-printed piece. Although you don't want the illustration board to hang over the edge, it is helpful to place it toward the left-hand side of the drawing table so that the head of the t-square is closer to the mechanical, allowing you greater control of the instrument. Such an arrangement also gives you more space at the right for the tools and materials you'll be using for the pasteup. (Naturally, if you're left-handed, you reverse sides.) Align the bottom edge of the illustration board with the blade of the t-square, and secure the board in position with push pins. (Push pins are recommended, rather than tape, because tape is more likely to pull away during the job, increasing the risk of misalignment.) The illustration board is now squared to the surface of the drawing board.

3

3. **Turn over the copy and place it on an illustration board. With a steel straightedge and razor, trim slightly away from the blue guidelines. Leave the copy tacked to the board.**

MARKING THE GUIDELINES

1. Square the illustration board to the drawing surface and attach it at each corner with push pins.

2. With a sharp 2H pencil, mark the dimensions of the page—the trim lines—and draw them on all four sides, using the t-square and triangle as guides.

3. Consult your layout for the placement and dimensions of the elements within the page. Use dividers to calculate the spacing.

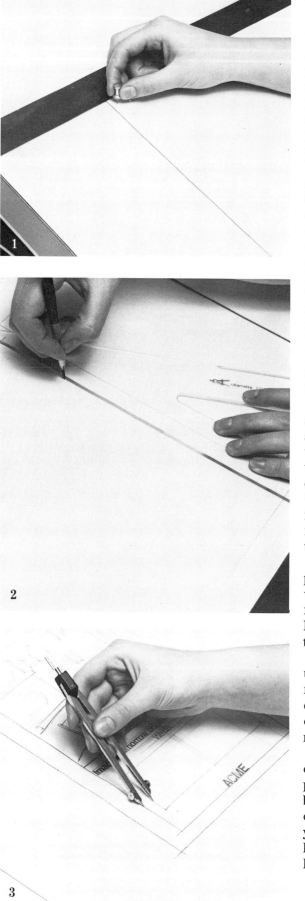

Marking the Guidelines

Guidelines drawn on the illustration board indicate the overall dimensions and size of the to-be-printed piece, as well as the placement of the individual elements within the piece. These overall dimensions serve as an accurate guide for the printer and for you as you place the individual elements on the page. With a 2H pencil, mark the dimensions of the page (the so-called *trim lines*), and draw them on all four sides, using the t-square and triangle as guides. Intersect the lines at each corner. To ensure a clean thin line, be certain the pencil is sharp. Draw the lines lightly but clearly, being careful to avoid making a deep impression in the surface of the board by exerting excessive pressure on the pencil. You may be inking some of these lines later, and any indentations in the board will produce defects in the inked lines.

If there are folds—and there aren't any in the simple pasteup shown here—indicate their position with dotted lines. If there are *bleeds*, where pictures run off the page, indicate these with dotted lines placed ⅛″ beyond the trim lines. (Marking folds and bleeds on a more complex mechanical will be shown in Chapter 8.)

Once you are satisfied that the pencil marks are accurate, ink in with the ruling pen the crop marks for the printer at the four corners. Draw these lines up to, but not touching, the penciled trim marks.

Inking is done before pasting up to avoid the risk of spoiling the mechanical with ink or incorrectly drawn rules. It also reduces any chance of smudging elements already pasted down.

Now, you are ready to mark off—very lightly with the sharp pencil—the placement of the copy blocks and art by measuring the layout, or tracing it as a template. Use your t-square and triangle for all horizontal and vertical marks. These lines, if lightly drawn, will disappear

when you clean up the mechanical later. Using dividers is a good means of transferring the precise spacing from that shown on the layout to that on the mechanical. It is far easier and more accurate than measuring the spaces with a ruler.

Pay particular attention to the placement of the display type: is it centered or justified, flush left, flush right? Have you accurately allowed for the spacing above and below the line?

After you've indicated all the guidelines, check once again. Your typesetter should have provided you with a type proof printed on a transparent sheet of acetate or transparent paper so that you can check the type for position. Lay this proof over the guidelines to be certain the elements will fit precisely as you drew them. At this time check the sizes of the artwork as well. If there are slight discrepancies in size, plan how you will resolve these differences in your mechanical. Most minor differences can be corrected by slight cropping.

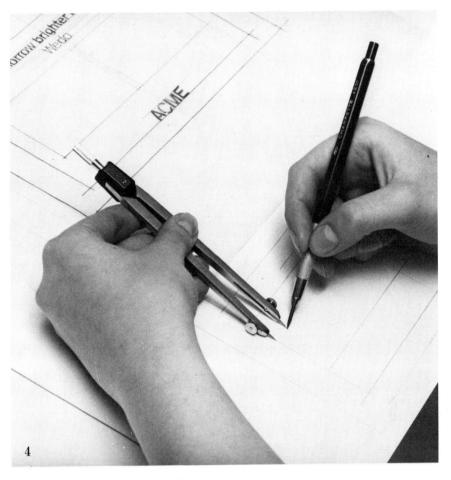

4. To transfer the space from the layout to the pasteup board, make interior marks with a 2H pencil.

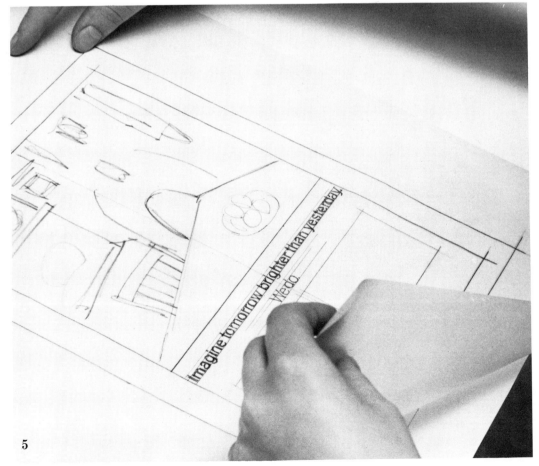

5. The layout tracing can be used as a template to check if all the elements have been indicated on the pasteup board and if the position and size of these elements match the layout.

"CROP" MARKS SHOW SIZE OF PAGE AND WHERE TO TRIM PIECE (BLACK INK)

6. Here the guide-lines have been marked for this simple 7″ × 10″ ad. Trim lines are marked in nonreproducible blue on all four sides; crop marks are drawn in black ink at each corner; and light pencil lines indicate the placement of elements on the page.

ALL LINES INSIDE THE 7″X10″ AREA ARE DRAWN IN NON-REPRO BLUE OR 2H PENCIL

AD DEPTH 10″

11″

CENTER LINE

HEADLINE

SUBHEAD

TEXT

CENTER LINE

LOGO

8½″

7″ AD WIDTH

Assembly

Prepare the illustration board by applying two-coat cement to the areas where copy will be pasted. Be certain to cover an area larger than the exact area itself so that all edges will adhere. After the cement has dried, reach for the copy that is highest on the page—the photostat in this case. You do this because elements are pasted from the top down so that you're never working over pieces of copy that have already been cemented to the board.

Carefully place the top edge of the trimmed and cemented photostat along the pencil guidelines, using the slipsheet method described in Chapter 5. If the stat is not square, lift the proof and lay it down again until you have placed it accurately on the board. Once you're satisfied that you have it right, flatten the stat onto the illustration board, and make sure all four edges are adhered.

Now lift the next element down the page—the display type in this case—and align the letters with the blue pencil line on the board. Be careful to place the *body* of the letters along the pencil line, not the ascenders or descenders. Lightly tack the type in place, and check with the t-square and triangle to be certain it is squared and in position. Now do the copy block.

After all the elements have been pasted down, remove the excess rubber cement with the pickup and erase any dark lines with the kneaded eraser. Be careful not to scuff or smudge the type. Remove the board from the drawing table and examine the pasteup again under a bright light. The excess cement you failed to remove will shine under the bright light.

Finally, make an overlay for the pasteup. Trim a piece of visualizer paper smaller than the illustration board, and attach it with masking tape to the top edge of the board.

Many artists take one more step by making an additional overlay of heavier paper. This overlay is trimmed on three sides to the same size as the illustration board; on the top side about three or four more inches are folded over the top edge of the board. This flap is then cemented or taped along the back.

You have just completed a simple mechanical. At first you may feel as if you are all thumbs, but with practice each of these steps will come more easily. Once you've mastered the basic elements of the pasteup, you are ready to proceed with a more complex mechanical.

On the following pages, the entire sequence of creating this simple mechanical is shown in detail, from cementing to creating an overlay.

ASSEMBLING THE MECHANICAL

1. Apply cement on the areas to which copy will be pasted.

2. Using the slip-sheet method, place a piece of tracing paper on the board, with only the top edge exposed.

3. Place the top edge of the stat down on the pencil guidelines. You always begin the mechanical with the top portion of the page in order not to work over elements already pasted to the board.

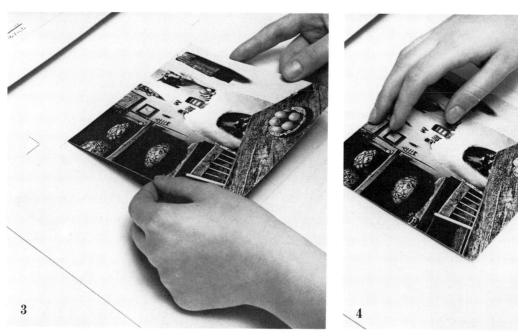

4. Gradually withdraw the tracing paper and tack down the stat as you go, making sure it's aligned properly. If it is not, lift the proof and begin again.

5. After you've positioned the proof properly, burnish it in place with the edge of the triangle. Protect the surface of the stat with tracing paper.

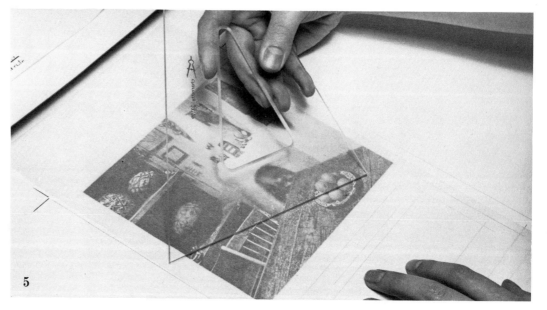

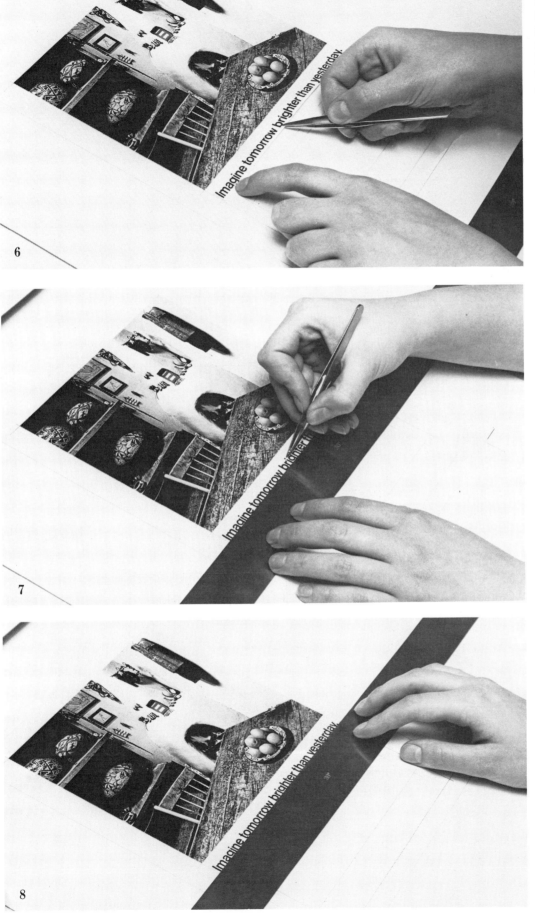

6. Peel away the trimmed copy from the cutting board and lift it with tweezers. Align the base of the display type with the penciled guidelines.

7. Using the t-square as a guide, push the copy with a pair of tweezers (or razor blade point) until it is precisely in position.

8. Check the horizontal alignment of the copy with the t-square, the vertical alignment with the triangle.

9. With the tweezers, lift the copy block from the cutting board and tack the top edge to the pasteup board, with the slipsheet below. Line up the blue guidelines of the trimmed copy with the guidelines marked on the board. Accurately aligned, the copy will be square vertically and horizontally.

10. Remove the slipsheet below the copy block.

11. Check the copy for horizontal and vertical alignment.

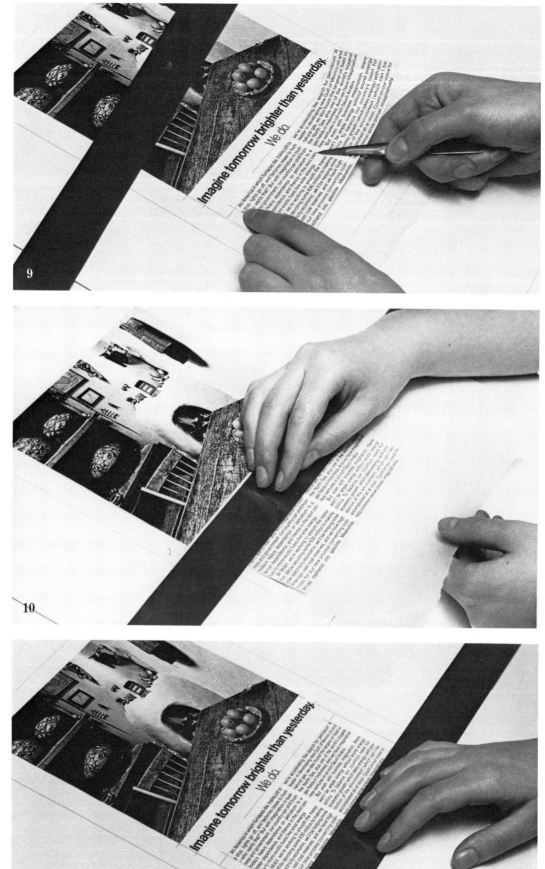

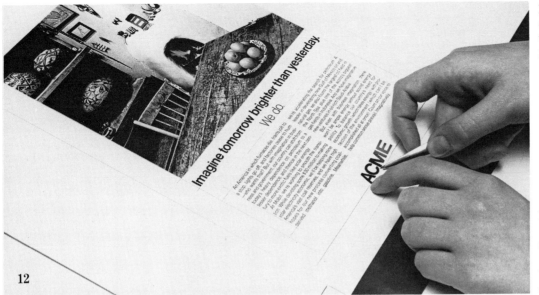

12. Place the last element of display type on the mechanical.

13. To be certain the copy is centered as desired, measure the space on one side of the word with dividers.

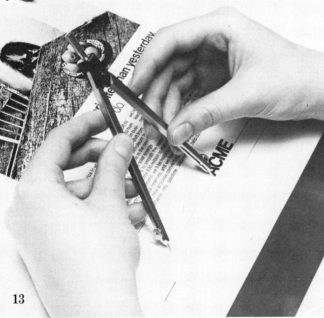

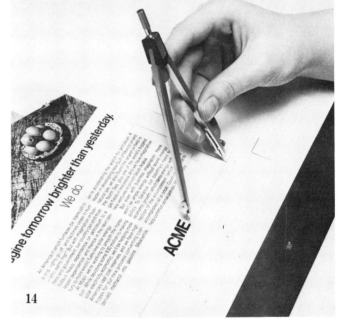

14. The space on the other side should be equal to it.

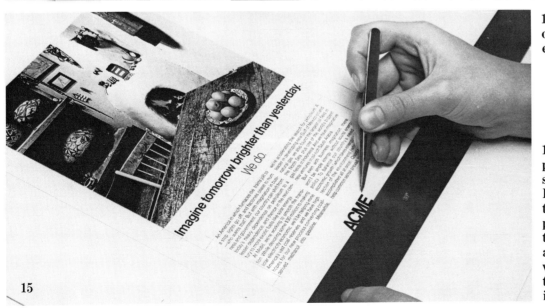

15. If the copy is not precisely centered, shift it into position. Hold the copy with the t-square as you push it with the tweezers. Check again with the dividers and continue the procedure until it is centered exactly.

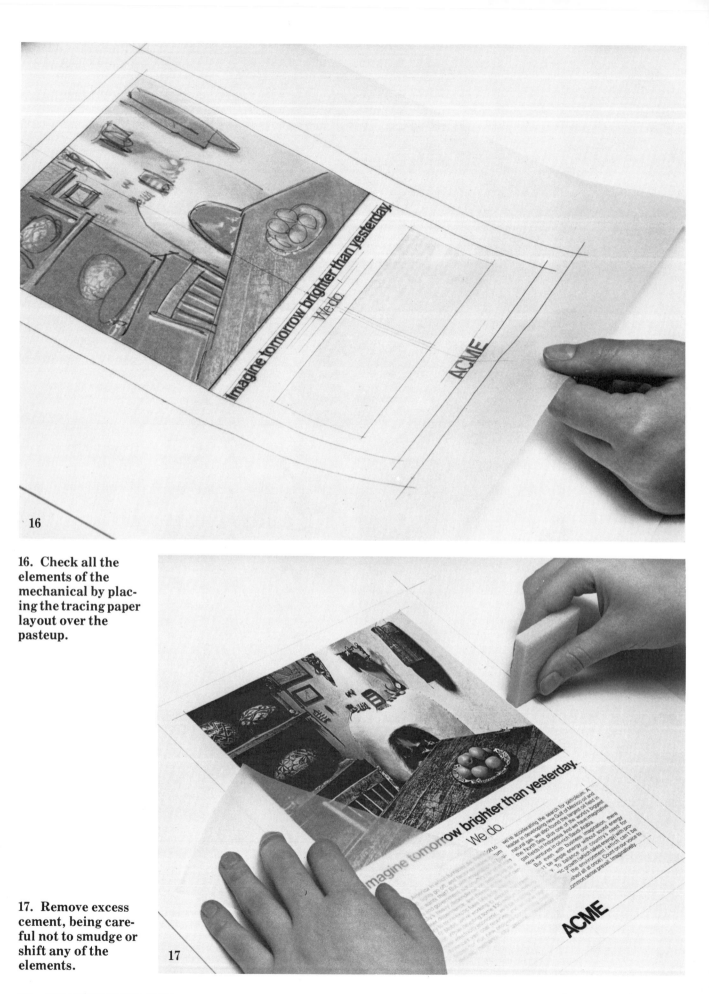

16. Check all the elements of the mechanical by placing the tracing paper layout over the pasteup.

17. Remove excess cement, being careful not to smudge or shift any of the elements.

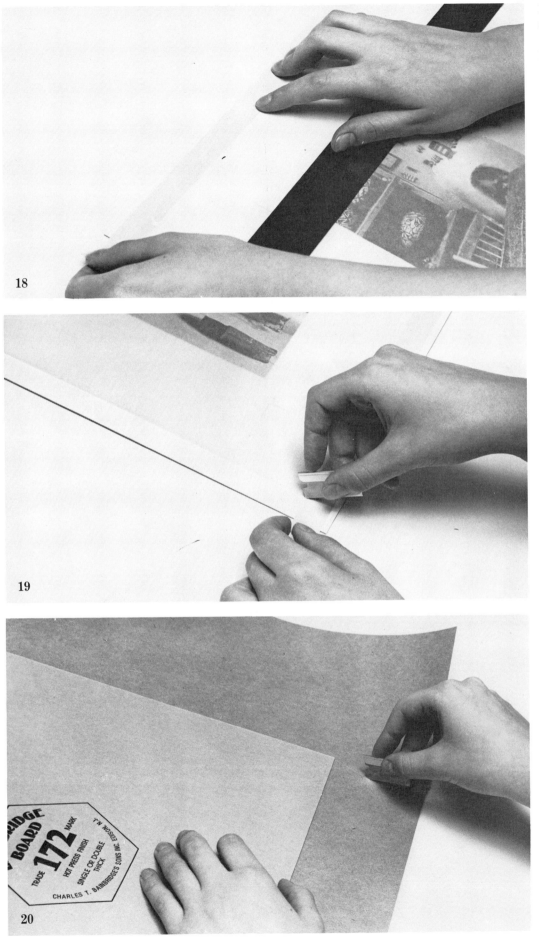

18. Now make a tissue overlay. Lay a sheet of visualizer paper over the pasteup and adhere it with a long strip of masking tape at the top.

19. Neatly trim off any extra tape at the top.

20. To protect the mechanical make an overlay of heavy paper that covers both pasteup and tissue overlay. Lay a sheet of heavy paper on the board and place the mechanical face down on the sheet. Line up two edges at the base of the board with two edges of the paper and slice the overhanging edge at the top.

21. Cement both the board and the flap and wait for each to dry.

22. Fold over the flap and remove any excess cement.

23. Now cut off the strip of heavy paper along the last edge of the board so that the paper is now flush on all sides with the board.

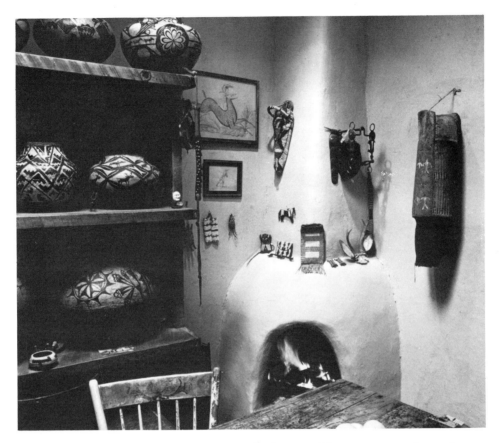

Imagine tomorrow brighter than yesterday.
We do.

An America in which furnaces die, trains jolt to a stop, lights go off, and factories cease to hum —who wants that? But with imagination in business and government, our country can shift from today's heavy dependence on petroleum to a lesser dependence, and thence in the next century to more exotic fuels like solar energy.

At Mobil, we're working to smooth the transition. While devoting some $30 million to making solar electricity economic, we'll be helping mine America's vast coal reserves, and we have high hopes for our new process converting coal-derived methanol into gasoline. Meanwhile,

we're accelerating the search for petroleum. A leader in developing new Gulf of Mexico oil and natural gas, we also found the largest oil field in the North Sea, plus one of the world's biggest gas fields in Indonesia. And we have imaginative new ventures in oil-rich Saudi Arabia.

But even with business imagination, there won't be ample energy without sound energy policy. To balance our country's need for economic growth (which takes energy) with protection of the environment (which can't be accomplished all at once). Count on our voice to help common sense prevail. Imaginatively.

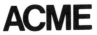

8: MORE COMPLEX MECHANICALS

The mechanical prepared in the previous chapter was a very basic single-color job. The skills covered in that section are basic to all pasteups and mechanicals, but additional skills are required for jobs in which other elements, such as surprinting, tints, or color, may be necessary.

You may discover that there are a variety of ways to prepare the same complex mechanical for the printer. Whether to use any overlay at all, or how many overlays to use, may vary according to the budget, the printer you use, or your personal work habits. The goal, with any of these methods, is clarity and simplicity. Before undertaking a complex job, discuss its preparation with the production manager or with the printer directly in order to be certain your method is the one preferred. Taking this step will save time and money in the end.

Organizing the Material

The greater the number of elements in a mechanical, the more important it becomes to organize them in advance. It's quite easy to confuse pieces of type while you're concentrating on the pasteup unless you're properly prepared. Follow these steps to set up your work area:

1. Take an inventory of the elements needed in the mechanical. Match the original art with the layout to be certain all pieces are at hand. As you take this inventory, match key numbers in the layout with key numbers on the art (A, B, C, or A1, A2, A3, for example). Be certain you've indicated key numbers clearly in the margins of the art. Now stack the art in sequence and place the pile near your work table.

2. If the type is inked, spray the repros with a light coat of workable fixative to prevent smudging. Are the repros complete? Check all type — display, text, captions, and page numbers — against the layout to be certain all elements are there. On the margin of the repros, make notes in blue pencil to yourself about alterations, if there are any: "extra space," "missing copy," perhaps.

3. Mark off blue guidelines on the copy blocks at each of the four corners with nonreproducible blue.

4. Cement the copy.

5. Trim the copy, using the t-square as a guide for cutting, so that you have squared-off copy blocks. Stack the piles of text copy in sequence separately from the other piles of captions and display type. Separate each board with tracing tissue.

6. With the piles of art and copy elements within easy reach — all marked, cemented, and trimmed — square up a sheet of illustration board and indicate the guidelines, bleeds, folds, and trim in pencil. Indicate halftone and copy areas in blue pencil.

7. Paste the individual elements at the top of the page first, moving down the page to avoid working over an area that has already been pasted down. The object here is to complete the pasteup on one entire page with a single squaring-up. This saves time and prevents errors later. By being properly organized in advance you should be able to prepare each page in one set-up, regardless of the number of elements.

In marking the guidelines for more complex mechanicals, use red ink to indicate bleeds ⅛″ beyond trim lines, blue ink for trim lines and the broken rules used to designate folds, and black ink for crop marks at each corner.

BROKEN LINE MEANS "FOLD"

"CROP MARKS" SHOW PRINTER TRUE SIZE AND WHERE TO TRIM PIECE

RED INK LINE INDICATES "BLEED" (⅛″ OUTSIDE THE "TRIM LINE")

NON-REPRO BLUE LINE SHOWS "TRIM" LINE

10"

10"

5"

SHADING SHEETS ON LINE ART

1. Shading sheets are available in a number of patterns. Take the full sheet and cut a piece somewhat larger than the area to be shaded. Peel away the backing and lift the shading sheet with the tweezers.

2. With your index finger, lightly press the sheet to tack it into position. Be certain the surface beneath the sheet is smooth and free of dirt.

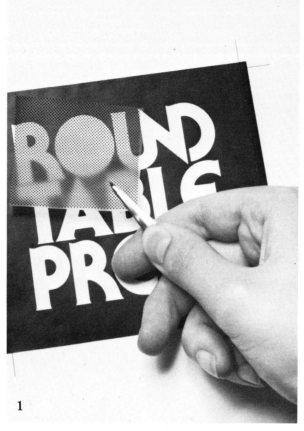

1

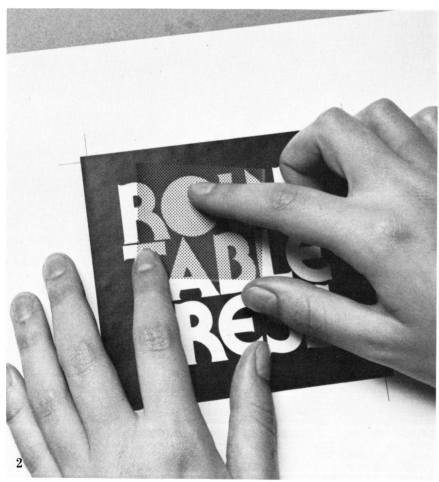

2

Shading Sheets on Line Art

When line copy requires a tinted area, you can apply a tint directly on the pasteup from a shading sheet. Manufacturers such as Zip-a-tone and Craftint produce hundreds of tints and patterns, ranging from dots and lines to stipples and cross-hatches, which are available in art supply stores. Tint sheets come in either black or white, the latter for reversed areas. Applied directly to the pasteup, these patterns are considered to be line copy. (For solid areas of tone, you can also use masking films, which are described later in this chapter.)

Be sure to apply the film over a smooth surface, free of dust, specks, or bumps. Cut out an area of the sheet that is slightly larger than the art being covered. Peel away the protective backing and place the sheet over the art being shaded. Carefully tack one corner of this piece with your index finger, and then gently tack the rest of the sheet in the same way. With the knife or razor blade, cut around the contour of the art and strip away the parts you don't want, careful not to damage the surface below with the edge of the blade. After all unwanted pieces have been stripped away, burnish the sheet into position.

As you burnish, trapped air may produce bubbles on the surface of the sheet. Using a needle, puncture the bubbles carefully to release the trapped air, and continue until the sheet has been completely burnished.

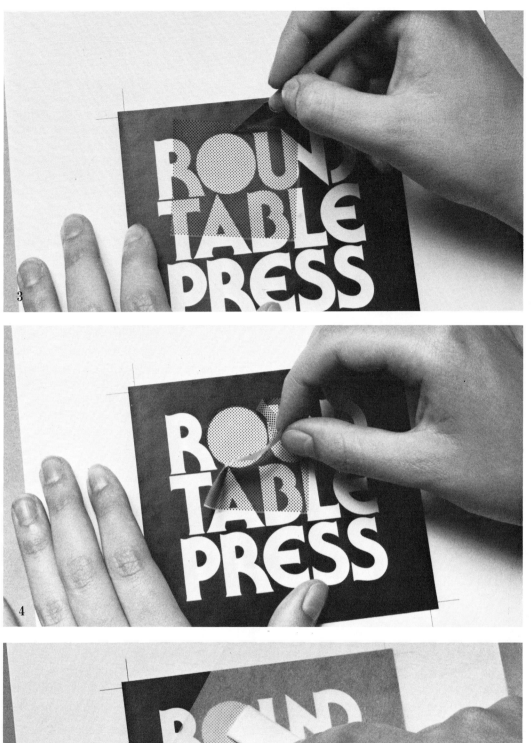

3. Using the knife, trace the contour of the art, penetrating the shading sheet without damaging the surface below.

4. Peel away the unwanted shading.

5. Place a tissue over the art and burnish the shading from edge to edge for firm contact.

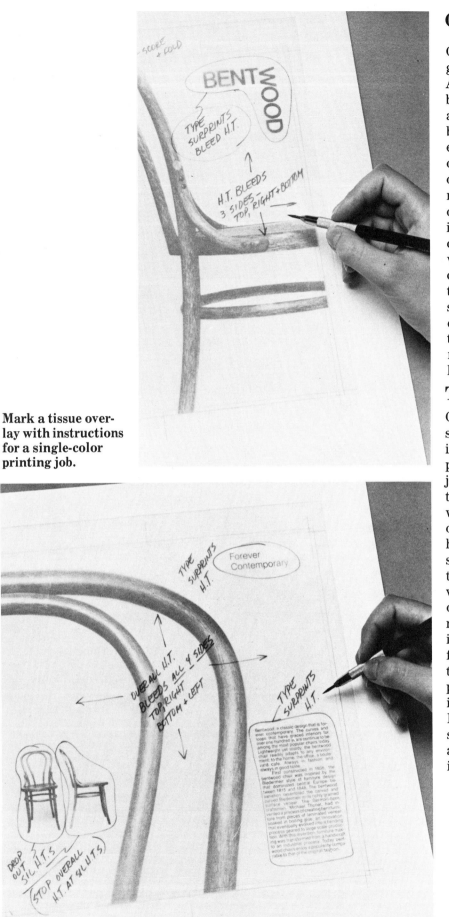

Mark a tissue overlay with instructions for a single-color printing job.

Overlays

One goal of your mechanical is to give clear and accurate instructions. As a general rule, you can do this best by placing as much information as possible on the single pasteup board. Yet if the job has too many elements, it may be necessary to use overlays. There are three kinds of overlays: the protective overlay made of a fairly heavy paper; a tissue overlay on which you write simple instructions to the printer; and a copy overlay, an acetate sheet on which you cement camera-ready copy. More than one overlay can be taped to a pasteup board, and often several overlapping overlays carry different copy and instructions to the printer. In more complex mechanicals, you'll be using overlays a great deal.

Tissue Overlays

General instructions to the printer should be written on the mechanical in the margin: "Shoot same size and print in black." That, for example, is just about as simple a set of instructions as you'll ever write. When you want to *differentiate* the handling of one area on the pasteup from the handling of another, write your instructions on an overlay. With the tissue overlay (which is made with visualizer paper) taped in position over the pasteup, mark the designated area and clearly write your instructions that apply to this area: for example, "type surprints halftone," "dropout halftone." The printer will follow these instructions in making the negative and plate. For a single-color job, using the tissue overlay is a straightforward and acceptable method of communicating with the printer.

Tissue Overlays and Simple Color Copy

Some color work is relatively simple to produce and therefore simple to prepare in the studio. A job that involves the use of two colors, for example, requires a fairly simple mechanical. Using a tissue overlay, you can indicate how the printer should handle color areas. By designating on the overlay which is to be printed in which color, you leave it to the printer to make separate negatives and plates. The operation is automatic and you are assured of accuracy. Obviously some copy—even with two colors—cannot be so easily handled (and we will show other examples later in this chapter), but most simple two-color jobs can be prepared with only a tissue overlay.

To prepare the art for a simple color job, place as many instructions as possible on the board, rather than on the overlay, especially critical items such as color choice, screening, scaling, etc. Overlays can be damaged or lost, and you'll want to prevent as many errors as possible from occurring in this event. To specify color, it's advisable to use a matching system that has a sample book of colors and ink mixing instructions for the printer. It is a proven method of obtaining the precise ink for the job. The Pantone Matching System is probably the most widely used; its sample book is available at most art supply stores. From the sample book, select the precise color, and tear out a swatch of it, on which will be printed the specific code number: "PANTONE 104C," or whatever color you have selected. Tape this to the margin on the board. Here you should also specify the screen: "PANTONE 104C, screened at 50%," for example. Now mark the placement of this color on the tissue overlay.

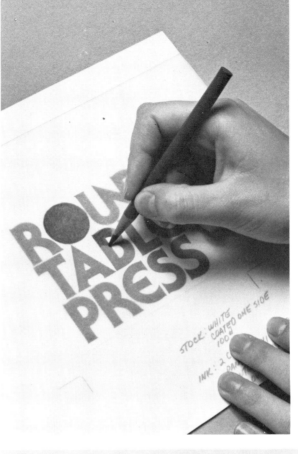

Color breakdown should be indicated on a tissue overlay.

For a simple two-color job, mark instructions in the margin on the board and attach color swatches. The printer will photograph the board for each color and will follow the overlay for instructions in stripping.

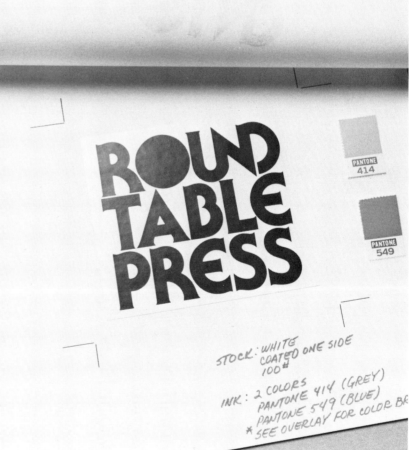

Copy Overlays

Copy overlays are used when elements that will be combined in the final reproduction must be handled separately during the production phase. Although a copy overlay may also contain instructions to the printer—like the tissue overlay—here the overlay itself is camera-ready copy. For example, if two elements are to be shot separately—one for each color, perhaps—one color can be prepared on the board, the other on an acetate overlay. The copy overlay is exposed and photographed separately from the art on the board. Separate plates are made from each negative.

Because they do not shrink, stretch, or tear, polyester films—such as Mylar, Cronar, or Estar—are recommended for copy overlays. A thickness of .005 inch is generally used.

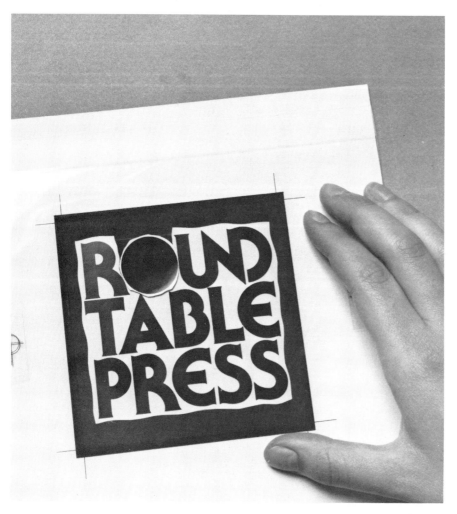

With more complex breakup of color, or where cost is a factor, separate out the art on a copy overlay.

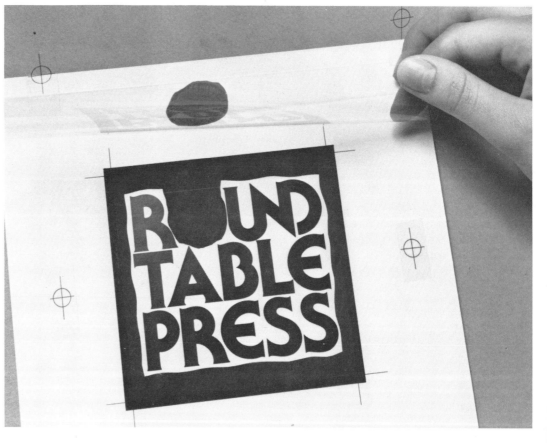

The copy overlay is a sheet of acetate to which type or art is pasted. The printer photographs the copy overlay separately from the art pasted on the board.

Registration

The separate elements of the mechanical must be precisely related to each other so that when they are combined in the final reproduction, they fit accurately. This is called *registration*: the separate parts fit precisely within the whole. If the alignment of any one element is incorrect, these pieces are said to be "out of register." Poor registration can be the result of a printer's error in making the negatives or plates, but it can also be the result of an inaccurate pasteup. To guarantee proper registration, place *register marks* (crosses) on both the board and the copy overlay. When the overlay is laid down on the board, the two register marks should overlap so precisely that they appear to be one. Register marks can be drawn with the ruling pen, t-square, and triangle. (A method of drawing register marks with a compass is described in Chapter 10.) Register marks preprinted on transparent tape are also available at art supply stores. Simply cut them from the tape and press them into position as shown here.

When all the work has been completed on the board, place register marks on two margins of the mechanical, outside the area that will be printed. Position the acetate over it, trim it so that it extends at least 1″ beyond the crop marks, and hinge the overlay close to the top of the board. (A strong 1″ cellophane tape is recommended for hinging.)

With the acetate flat against the board, place the register marks precisely over the marks below. Even if the acetate is removed, it can then be accurately positioned by aligning the register marks.

The first step in preparing a copy overlay is registration. Place register marks (here register tape is used) in the margins on the board.

Hinge the acetate overlay to the board, lay it down on the board and place register marks on it in precisely the same position as the marks below. The marks on the acetate and on the board should appear as one. The overlay is now registered to the board.

Ruling Overlays

When purchasing overlays, be certain to select those that are treated to accept ink-ruled lines on one or both sides. Ink will spread on untreated polyester.

Overlays can be clear or frosted. The frosted surface contains a "tooth" that makes the surface somewhat less slippery and easier to ink. Surfaces that are treated on both sides may be preferable if you want to make pencil guidelines on one side that you'll eliminate after you've inked over the lines on the other side.

With frosted film, ink lines may not adhere consistently. The film easily picks up oil from fingertips, which resists ink. Therefore, before beginning to ink, rub the surface of the film with rubber cement thinner or alcohol applied to cleansing tissue or cotton swabs. Do not clean the surface with an abrasive, because such a rough substance damages the surface of the film.

Before ruling an overlay, tape down all corners to flatten the sheet securely. (Corners tend to curl otherwise.) Test some lines on an edge of the overlay to get the feel for the touch of the pen against the plastic surface.

To erase ink from film, you can apply a liquid erasing fluid that eliminates the ink, yet permits you to ink over it later. Household window cleaners—such as Windex—can be substituted for liquid eraser and applied with Q-tips or cotton swabs.

Tints on Overlays

Let's consider a tint block that you want printed around artwork. By preparing this block separately on an overlay, you save stripping time at the printer. First outline the shape of the block in nonreproducible blue on the board as a visual guide. After the overlay is taped and registered, use the lines as your guide to prepare a patch on the overlay. This patch can be brushed in with an opaque ink to the shape you require, or masking film can be applied as described below. The completed patch on the overlay will be photographed solid or through a screen, whatever you specify, and stripped into the position indicated on the overlay.

Masking Film

For the patch described above, masking film tends to provide a cleaner result than your own handiwork with the brush or pen. Use red blockout film that is a transparent, self-adhesive plastic and registers on film as black. (Amber- or ruby-colored films are types of red blockout film.) Cover the art or mechanical with acetate, register the overlay, and then cut and peel away a section of the blockout film large enough to cover the desired area. Lightly burnish the film on the acetate over the designated area and cut the film to the desired contour with a razor or knife. In cutting, only light pressure is required. (Be careful not to cut into the acetate.) Since the film is transparent, you can follow the guidelines while cutting, and the edges will be sharp. Peel away excess film and rub off any residue wax with a clean rag. If air bubbles surface, pierce them with a push pin and press the film flat to make sure that the air has escaped. This colored film is recommended because it's easy to use and because it creates excellent copy for printing.

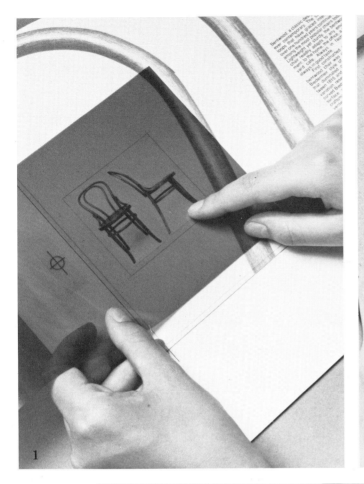

APPLYING MASKING FILM

1. To apply masking film to the copy overlay, determine how much film you will need by placing the transparent sheet over the appropriate area.

2. Cut a piece of film sufficiently large for the job.

3. Peel away the film from the protective backing.

4. With a tissue slip-sheet below, gently lower the film into position on the acetate overlay.

5. Tack the film down with your fingertips.

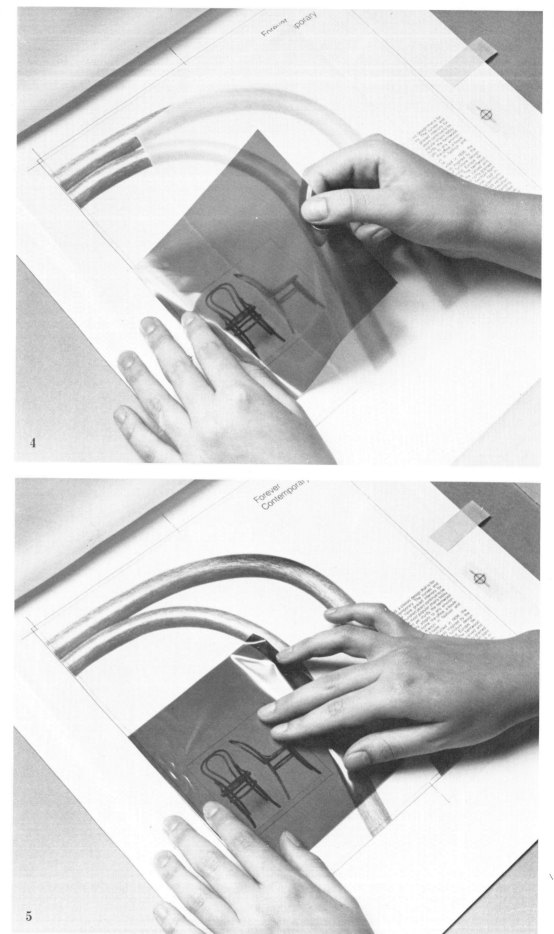

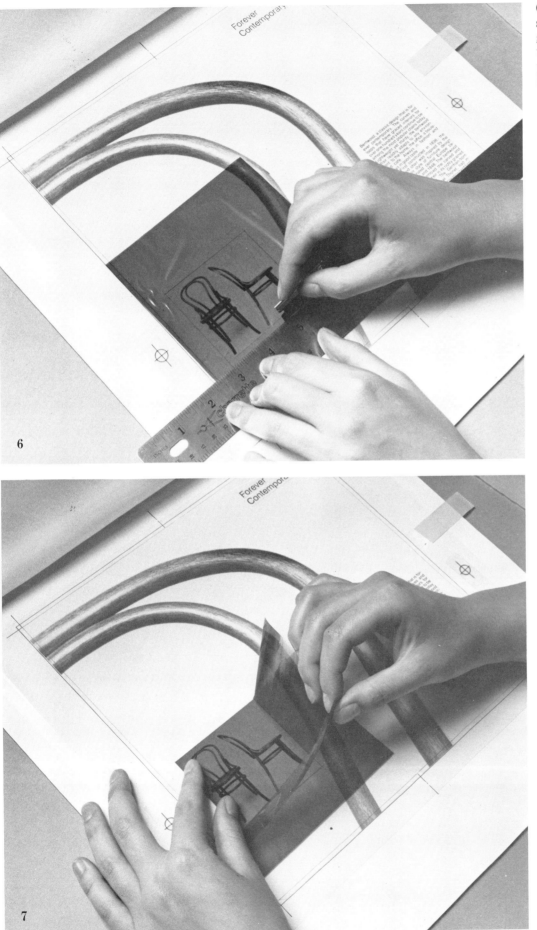

6. Using the straightedge as a guide, cut the film to cover the image precisely as shown below.

7. Peel away excess film.

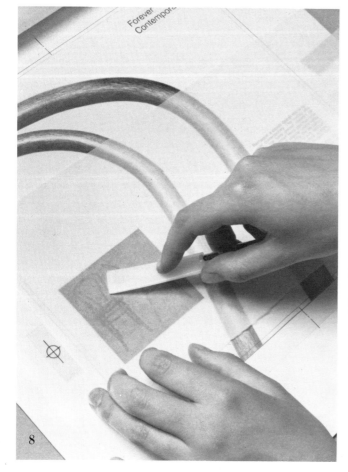

8

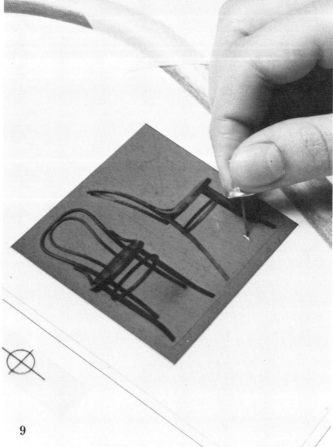

9

8. Place a tissue over the film and burnish for even adhesion.

9. To remove an air bubble, prick a hole in the bubble with a push pin.

10. With the acetate overlay registered, the masking film may be shot separately by the printer.

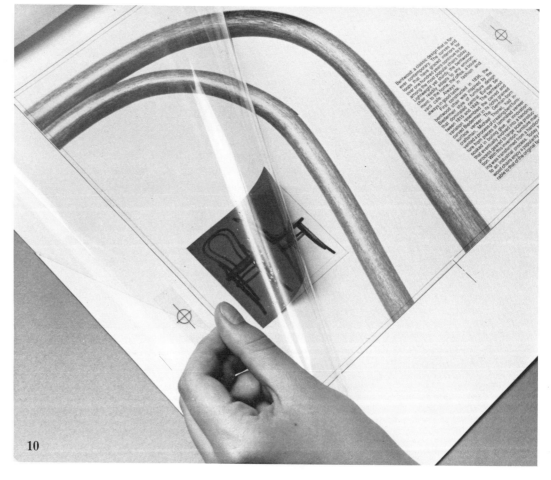

10

Preseparated Color

As we described in the section on process color in Chapter 4, the printer automatically separates the four colors—black, blue red, and yellow—from the original art with filters placed in the camera. This method of color separation is used for continuous tone art and is relatively expensive. The client may choose instead to publish flat-color work, rather than continuous tone, and have the color *preseparated* in the studio while the camera-ready art is being prepared. (Children's books and greeting cards, for example, are frequently printed in color from preseparated art.) With a series of overlays, the artist provides the artwork in preseparated form. The standard procedure is to prepare the black on the board and then use individual overlays for each of the remaining colors.

With more than one overlay, the sheets are taped on as many sides as needed, with only one on each side. The overlays are registered, the color areas are drawn, and a color swatch is taped to each overlay to identify the desired ink. The overlays, therefore, become camera-ready copy, and the printer shoots each overlay individually and prepares a plate for each, following procedures that are identical to those involved in single-color work. Only the inks distinguish this from one-color printing. When the art is photographed, these blocks may also be screened to provide the percentage of tint you've specified in any color.

Preseparating color can be an art unto itself. Precision and care are required in cutting the film to the precise shape, and being able to anticipate what will happen when overlapping more than one color on a single area requires considerable experience.

To prepare mechanicals for preseparated colors, first draw the overall scheme on the board. Here shading sheets have been applied as well.

Each color is prepared on a separate overlay that has been registered to the board below. Here is the first color overlay.

Here is the second overlay of color, also registered to the board below. Color areas have been indicated with masking film.

Here is the third overlay of color, also registered, with additional linework indicated as well. (Art preparation by Nick Fasciano. © Mobil Corporation.)

Line art on board.

10 percent black on overlay.

50 percent black on second overlay.

Combination of all three.

Keylines

We have learned methods of creating complex combinations with copy overlays and preseparated color overlays. However, there are times when too *many* overlays make the instructions confusing. In this instance it is preferable to eliminate *all* overlays and prepare the work on a single board. This is called a *keyline mechanical*, and the printer is required to perform more extensive camera and stripping operations than with preseparated overlays. Although this means increasing the printer's costs, keylines can also be used when time is a factor (you can prepare keyline mechanicals more rapidly than color separations without loss of quality) or when the registration is extremely critical.

The most complicated color in the art (generally the black) is prepared on the mechanical, just as it would be for a basic one-color pasteup. The other colors are also indicated on the board, but these are outlined (*keylined*) with red ink. (These are also referred to as *holding lines*.) Using colored pencils on a tissue overlay, indicate to the printer which are the colors desired for which elements. Tape color swatches to the board, keyed to the notations on the tissue overlay.

Using the red keylines as a guide, the printer photographs the single board as many times as there are colors, blocking out the unwanted sections in each shot. The keyline (or holding line) itself will not be retained.

Keylines can be especially useful when hairline register is required. This is a precise registration that is necessary when two solid or tinted colors butt against each other.

If not accurately registered, the color will not touch, creating a white space between them, or the colors will overlap creating an unattractive line at the juncture.

For a hairline register, draw a fine keyline precisely where the two colors are to touch. The thickness of the line functions as the overlap. Opaque or mask each color with a wavy edge up to, but not touching, the keyline (a ⅛" space is standard). The printer will provide the accurate registration required.

A keyline can also be used to indicate type printed over a solid tone. Here the area on the mechanical is filled in with solid black. (Masking film can also be trimmed and adhered to the board to indicate a block of solid tone.) Trim around the type with a jagged edge and paste it over the solid black or masking sheet. The uneven edge tells the printer that the tone continues beneath the copy.

The same process can also be used to print type on a halftone. Type trimmed with a wavy edge can be cemented over a photostat to indicate a surprint over or drop out from a halftone. Be sure to tell the printer which you want.

Any line art can be trimmed with a jagged edge and pasted over a tonal area in the same way. The uneven edge tells the printer that the two elements touch or overlap and that he should provide the register.

A keyline is a mechanical in which all elements are placed on the board. Colors are indicated on the board with keylines, not with overlays, and the printer performs all shooting and stripping operations using this single board as a guide.

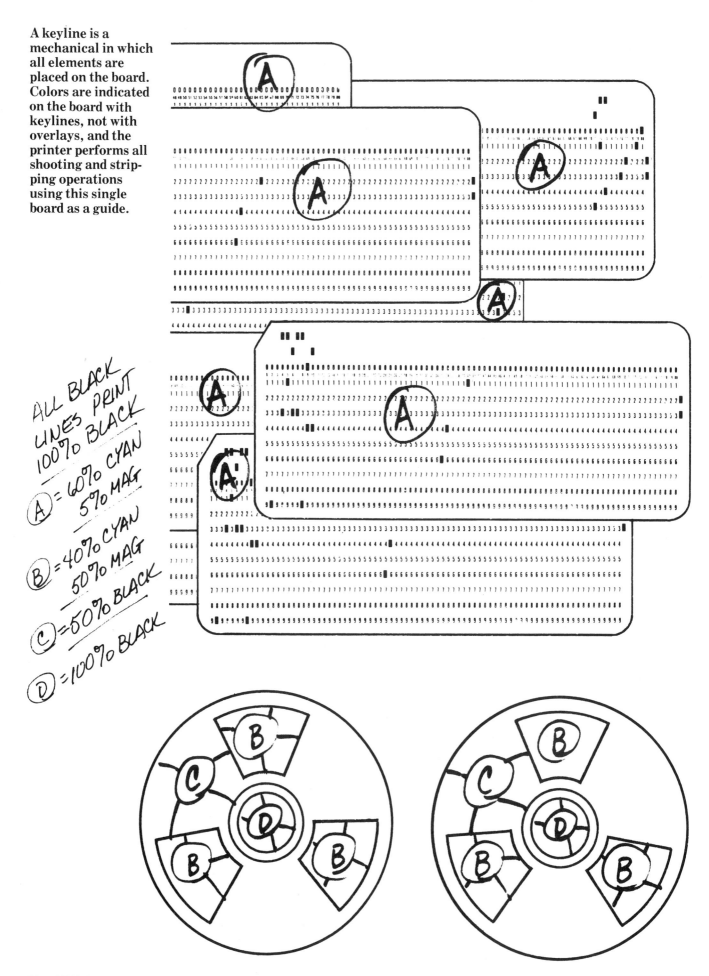

ALL BLACK LINES PRINT 100% BLACK

A = 60% CYAN 5% MAG

B = 40% CYAN 50% MAG

C = 50% BLACK

D = 100% BLACK

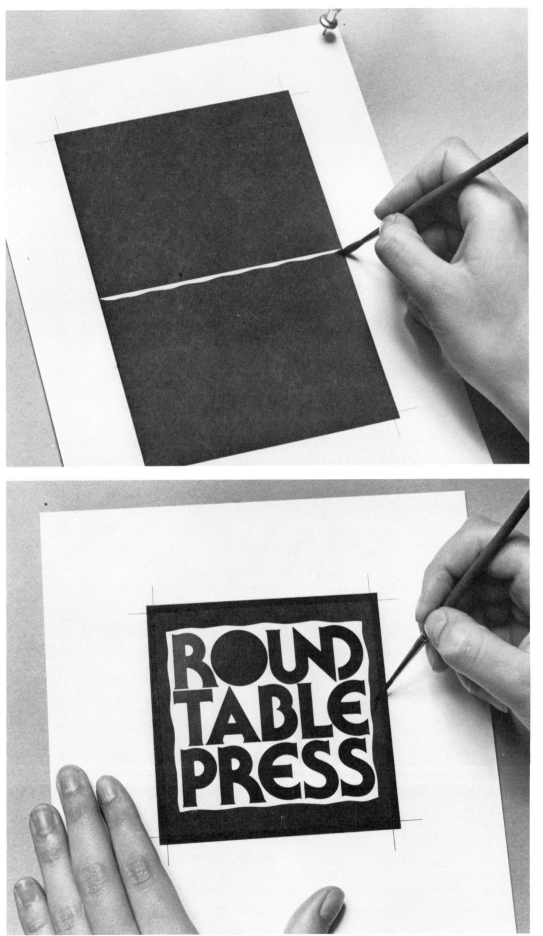

Keylines are used to
show a hairline reg-
ister in which two
solid or tinted colors
butt.

A keyline is used to
indicate type printed
over a solid tone or
over a halftone. Trim
around the type with
a jagged edge and
paste it over the solid
black or masking
sheet below.
The uneven edge
tells the printer that
two elements touch
or overlap.

9: ERRORS, CORRECTIONS, AND CHANGES

Corrections are more easily made with one-coat cement than with two-coat. Before beginning, prepare a cutting board that will make it easier to work with the sticky one-coat. Stretch strips of masking tape across a piece of illustration board.

Regardless of the type of work passing through your studio, regardless of all the precautions you take, regardless of the client, errors are inevitable. Changes are inevitable. So many elements passing through so many hands always increase the chances for error and the likelihood of changes. "Change the word *is* to *was*"; "make this line longer"; "change the size of this picture"— these are a few of the typical alterations you can expect (and expect regularly!).

Obviously, many changes in type can be made by the typesetter. But this may not always be the practical solution. Time pressures and cost factors may prohibit the luxury of having the typesetter make typographic corrections or changes. You can expect to perform a certain amount of this work at the drawing board.

For these reasons, knowing how to make efficient and neat changes in the type on the pasteup is a valuable addition to your studio skills.

Handling Small Pieces of Type

Making typographic corrections generally requires that you cut up a small piece of reproduction copy, cement the piece, carry it to the pasteup, and then paste it into its precise position. Handling these small pieces can be a problem unless you develop some techniques.

Small pieces are handled most easily with one-coat rubber cement. Coat the back of the type proof with the cement and allow it to dry face down. (Remember: one-coat sticks to everything, so be careful where you put the piece!) Prepare a cutting surface by tacking down strips of white tape on an illustration board and place the dried proof face up on this surface. Cut out the desired character or characters, using the t-square and metal triangle. With the corner of your razor blade, dig gently into a top corner of the small piece and lift it from the cutting board. (If you stab the proof firmly with the razor, you'll get a fairly firm grip on it.) Now you can carry it to the mechanical and lay it in position.

Fold the strips of tape over the edge of the board and press the edges of the tape down on the other side.

To pick up a small piece of type, dig gently into the corner of the repro with a razor and lift away.

REPLACING A CHARACTER

1. Cement the back of the correction proof with one-coat.

2. After the proof is dry, turn it over and place it on the cutting surface. Find the character to be removed.

3. Cut out the character, using a t-square.

The Mortise

If you paste a piece of copy directly over another, it can create a shadow on the pasteup that will register in the camera as a black line. It is preferable in making alterations to fit the type into a *mortise*, a hole cut into the old copy that provides a slot into which the new copy is placed, so that there is only a single rather than a double layer of paper. The new copy is then flush with the surface of the proof. A mortise also makes it easier for you to position, space, and align your type, because the parallel cut marks provide a guide for lining up the new copy with the old. Because a mortise provides a parallel "track" along which the type can slide, this procedure is called *railroading*.

With your t-square as a guide, make two horizontal cuts, one above and one below the letter or letters to be replaced. These cuts may extend beyond the characters, but be careful not to cut through ascenders or descenders of nearby letters. Now make cuts on either side. You should use a metal triangle to be sure of a square cut, but often you'll be required to make a freehand cut between characters because of their proximity.

Apply a small amount of thinner to a corner of a razor blade, and insert it under the top right or left corner of the piece you just cut. Lifting gently, peel away the piece as the thinner flows under the proof. When the area dries, it is ready to accept a piece of new copy the same length as that removed. If you cut the new copy in the same manner — lining up the t-square above and below the ascenders and descenders and slicing carefully to the left and right — the new piece should fit neatly into the mortise. When you're satisfied that the piece has been placed precisely, put a clean tracing tissue over the work and press the patch firmly in place with the back of your fingernail or with a burnisher.

4. Lift away the character with the corner of the razor. Use a drop of thinner to help loosen the paper.

5. Find the new character to replace the old and cut it out, using a t-square.

6. Lift the new character with the corner of the razor blade and drop it into the mortise.

7. Push the character into place with the razor blade, lining it up with a straightedge.

8. After the correction is aligned, place a piece of tracing tissue over it and burnish it into position.

CORRECTING A TYPE PROOF

1. Find the word to be corrected on the proof. Place this on an illuminated light box. (Note: We have simulated a light box here to show the procedure better.)

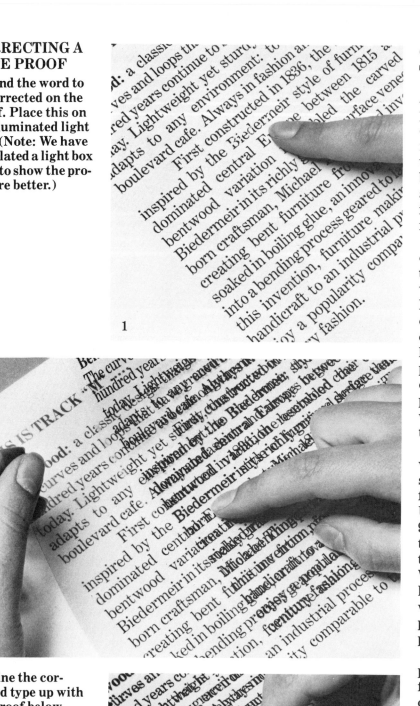

2. Line the corrected type up with the proof below.

3. Holding the razor at a 90° angle, cut out the word, making sure you cut through both proofs.

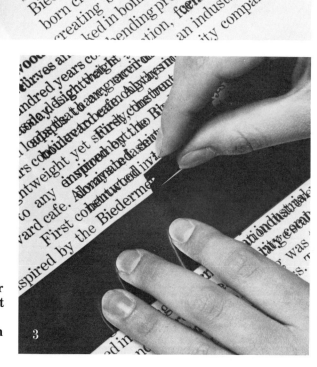

Corrections in the Type Proof

As you prepare your repros for pasteup, you may notice that a change is required on the proof. The most efficient method of making these corrections is by using a light box. If you happen to have access to a light box with a glass diffuser and if the corrections are fairly simple, follow this method:

Place the proof to be corrected on the light box. Find an extra proof that matches the size, style, and weight of the proof to be corrected. Locate the correct character on the extra proof and place it over the character to be corrected on the light box. Carefully shift the top proof until the lines of type match each other perfectly. With a little practice, you'll master this step without the use of a t-square and triangle.

Applying pressure to the proofs with one hand, make cuts on all four sides of the letter, always being careful not to cut into adjacent letters. Use a new razor blade and hold it at 90° to the proof so that a slice into the top proof will cut directly into the same place on the bottom proof. With the corner of the razor blade, lift out the correct character and with the other hand move the top proof to one side. Turn the bottom proof face down on the light box.

Put the correct character in place face down. When you're satisfied that the placement of the character is correct, tape it in position with correction tape.

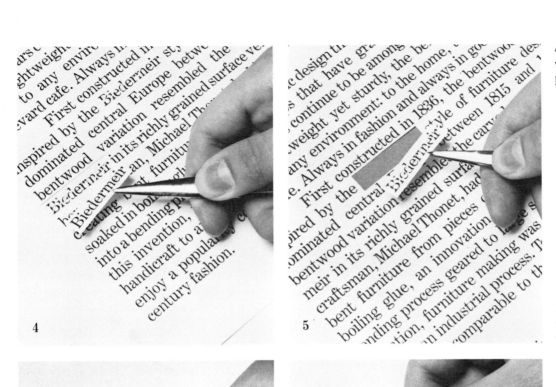

4. Lift away the word from the top proof.

5. Lift away the word from the bottom proof.

6. Turn over the bottom proof and place the new copy in the mortise.

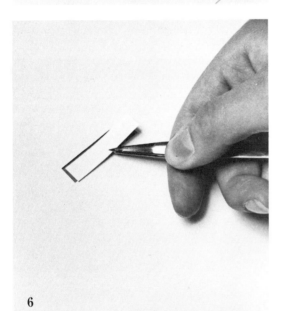

7. Tape the new copy into the proof with transparent tape.

8. The type proof is now corrected without any visible marks.

CORRECTIONS IN THE TYPE PROOF **127**

Spacing Out Letters and Words

Not all changes and corrections will involve replacing characters or words of the same length. "Change *have* to *had*" is a very common alteration. Here three letters replace four. Remove the four letters and drop the three-letter word into the mortise, centering the word so that there is equal space at the left and right.

Replacing a long word with a short one requires that letters be spaced out (you must add space evenly between letters).

There will be times, of course, when greater spacing out may be required, and other words in the line will have to be cut apart and spread out to cover a greater area. The type may simply run short, and words must then be spaced out to fit the layout. As you do this, be certain to keep the words square—don't let them lean or tip. A tight mortise and well-trimmed copy will help here.

REMOVING A CHARACTER

1. To make a mortise, cut the full length of the line in the original proof, using a t-square and triangle.

2. Cut the word "have" and remove it from the original copy.

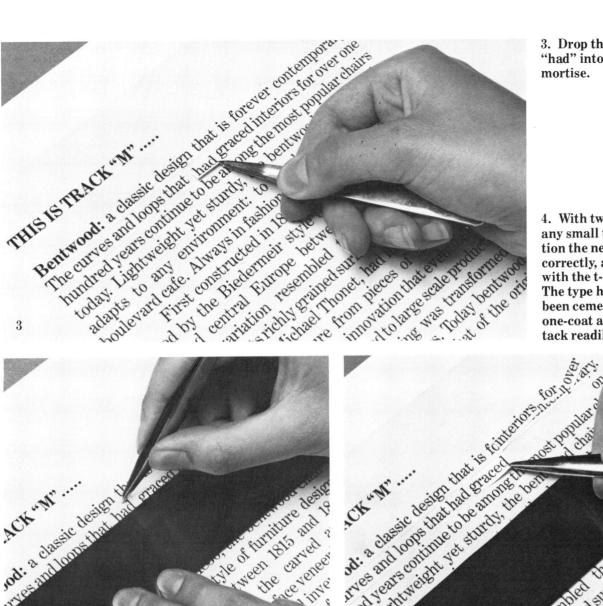

3. Drop the word "had" into the mortise.

4. With tweezers or any small tool, position the new type correctly, aligning it with the t-square. The type has already been cemented with one-coat and should tack readily.

5. Respace the words in the mortise, adding fractional spaces between them, to compensate for the shorter word that has been substituted.

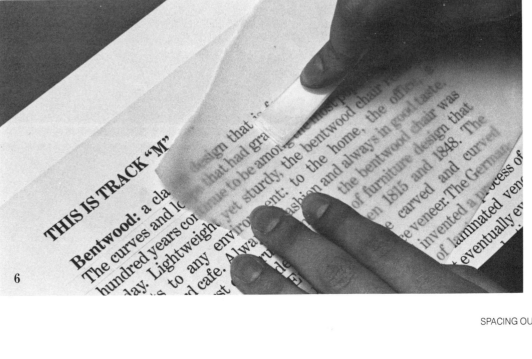

6. After the words have been evenly spaced, burnish them permanently into position.

Closing Up Space between Words and Letters

When the new copy takes up too *much* room and must be respaced to fit—as in "change *is* to *was*"—it is slightly more difficult than the reverse because it means replacing two letters with three (the latter including the wide letter *w* as well). To make room for the larger word, you must remove space from between the other words on the line. Removing space between words must be done carefully, because the words will run into each other if too much space is taken away.

With more type, you may have to close up space between letters, as well as words, to make room for the longer word. "Change *had* to *have*" means reducing the space between individual characters.

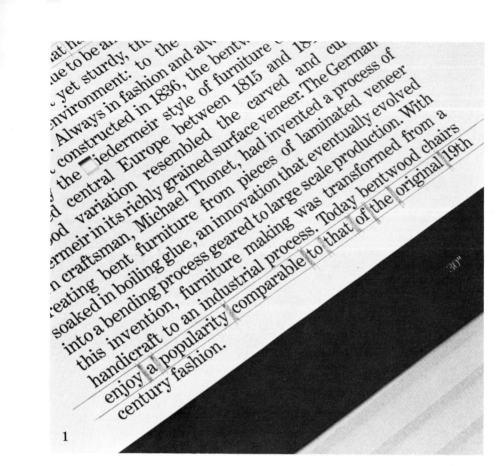

1

ADDING A CHARACTER AND REARRANGING

1. Here we are substituting words that add one character to the line. First locate the places from which space may be closed up to provide room needed for the additional character. Make vertical cuts between words.

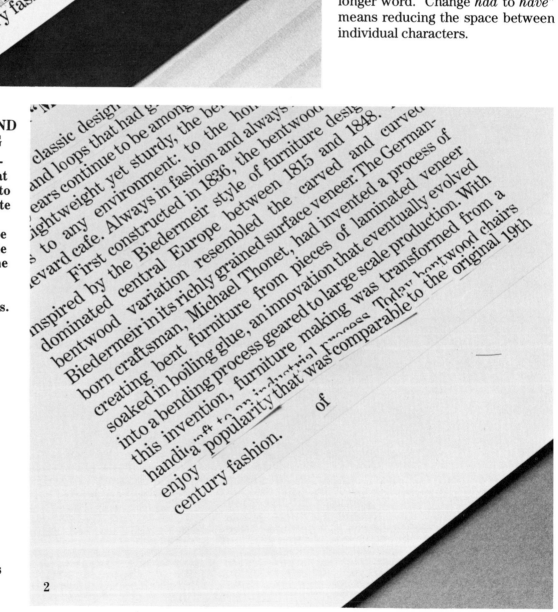

2. Place the words in their new sequence.

2

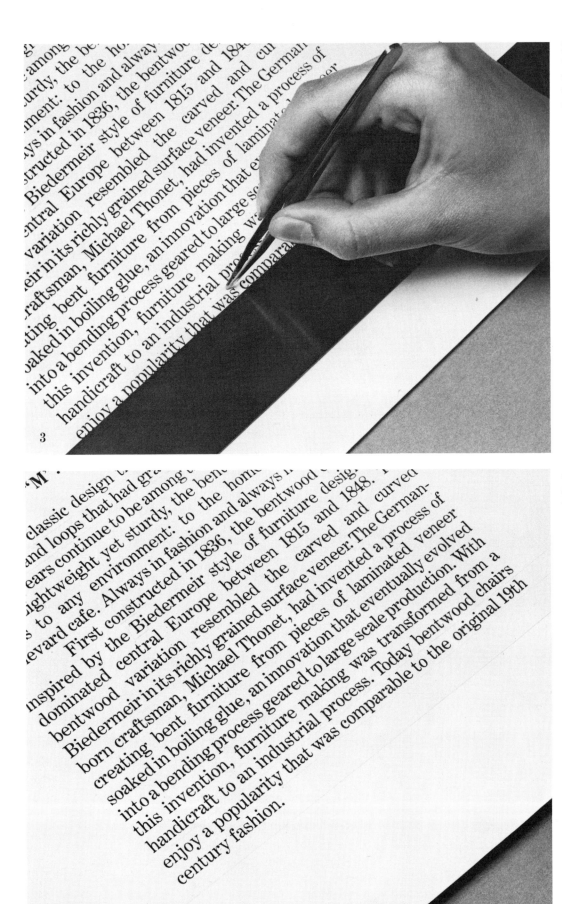

3. Align the new words with a t-square and position them with tweezers.

4. Burnish into position, the correction is indiscernible.

ADDING SPACE BETWEEN LINES

1. To space out lines of type, first cut each line and remove with thinner and a razor. Place the lines in order on another board.

2. Mark off the desired spacing with dividers.

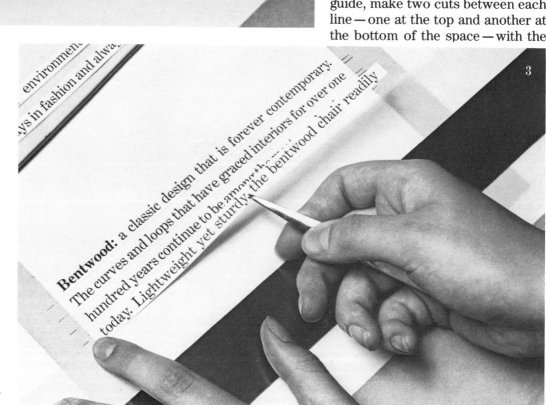

3. Lay down the lines as indicated by the marks.

Respacing Lines

There are many times when the lines themselves must be adjusted. Space *between* the lines must be closed or opened up, or line lengths must be changed to *break* (divide) lines differently.

Because, with these changes, you tend to handle larger pieces of proof than when changing characters, you can apply this handy method to reduce or expand the space between lines:

To calculate the space desired between lines, write down the total amount of depth you want. Measure the depth of the type you now have and in this case subtract the first figure from that number. Divide the difference by the total number of lines to arrive at the amount of space to be taken away from each line. (In the next chapter we present a spacing gauge that will make this task easier. Refer to the section called "Handy Spacing Gauge" if you intend to respace several lines of copy.)

Cement the proof to a piece of bond paper, and square up the sheet on the board. Using the t-square as a guide, make two cuts between each line — one at the top and another at the bottom of the space — with the

razor, and apply thinner to the proof. Remove the excess paper between the lines; then, with the corner of the razor, slide the lines closer to each other, retaining the position of the top line. Use dividers (tension dividers that do not slip easily) to be sure each space is the same, and use the t-square to be sure each line is aligned properly. After the respacing is finished, cement the bond patch to the pasteup.

To open up space between lines, follow the same procedures as above, but make only one cut between the lines and move each line down to allow a uniform amount of space between them.

To change line lengths, you'll use techniques similar to those described above. "Break these two lines into three" is a common alteration, or the reverse: "Combine these three lines into two." Slice the lines above and below, breaking the words at the desired point or counting characters if necessary, and shift the pieces to their new position. Only after much practice will you become really expert at respacing words and letters. In the end, it's almost entirely a matter of judgment, and success depends on trial and error. If it looks right, it probably is!

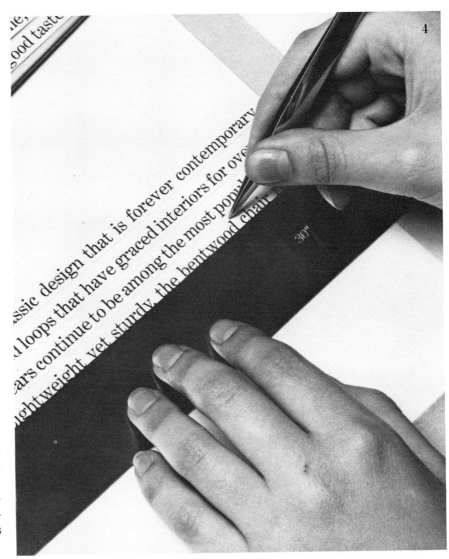

4. Use the t-square to accurately align the copy.

Bentwood: a classic design that is forever contemporary. The curves and loops that have graced interiors for over one hundred years continue to be among the most popular chairs today. Lightweight yet sturdy, the bentwood chair readily adapts to any environment: to the home, the office, a boulevard cafe. Always in fashion and always in good taste.

5. The final copy with additional line space.

REBREAKING LINES

1. To break two lines into three, cut out the block of copy and place it on a cutting board.

Bentwood: a classic design that is forever contemporary. The curves and loops that have graced interiors for over one

1

2. Mark guidelines in pencil for the new arrangement and place the copy into position flush left.

Bentwood: a classic design that is forever contemporary. The curves and loops that have graced interiors for over one

2

Scratching Out

Not all changes require new copy. Very simple alterations can be made directly on the original by scraping away a letter or punctuation mark with the razor blade. *Scratching out* is generally used for total deletion or for cleaning up. As you scratch the surface of the repro with the razor blade, apply only light pressure to avoid cutting into the fiber of the paper itself. The camera registers a hole as a black mark.

Black Ink and Opaque White

Handled with extreme care, paint or ink can be used to make changes in type. A touch of the technical pen can create a period, and an unwanted letter can be struck out with opaque white.

Final Appearance

The final appearance of the mechanical is an important sign of an accomplished artist. Cleanliness and neatness are the goals. Cut marks, white-out tape, smudges, and loose corners are all to be avoided. For extensive alterations, perform cutting and pasting operations away from the mechanical; then place them on the pasteup as a single unit.

After all, not all errors occur because someone *else* made them! Fatigue, distraction, and time pressures are only a few reasons why even the most experienced artist can make errors at the drawing board. Here are the most common mistakes made in pasteup. Study them carefully and compare them with the work you have performed:

- Type not aligned properly
- Type not spaced properly
- Unclear instructions to the printer
- Dirty rules
- Shadow cast on overlapping edges
- Smudges
- Construction lines not erased
- Dust collection on tape
- No holding lines on art
- Crop marks missing on a corner
- Excess rubber cement not removed

Develop good working habits so that these errors don't occur. Your performance will be judged by the final results.

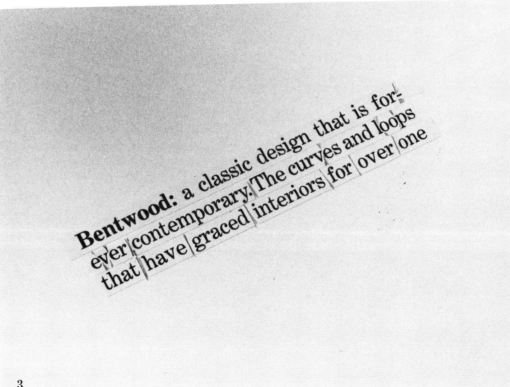

3

3. Respace every word so that each line is also flush right.

10: TRICKS OF THE TRADE

1

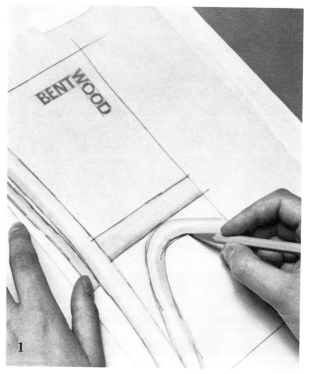

1

TRIMMING PHOTOSTATS

1. To trim a photostat to the size desired for the layout, place a sheet of tracing tissue over your layout and trace the broad shapes below. Trace the borders of the layout as well.

There are a number of procedures in the studio that can make your job much easier. These shortcuts are the tricks of the trade. Here are some situations you may encounter and some simple solutions.

Trimming Photostats

You have made a layout that shows a detail of artwork. The photostat arrives of the full image and you want to crop it to size precisely as shown on the layout so that you can place it in position. Here is a simple technique for trimming the photostat.

Place a sheet of tracing tissue over the layout, and with a pencil, trace the broad shapes. Lift the tissue from the layout and place the tracing over the stat, matching up the shapes on the stat with those on the tissue. Tape the tissue in this position. With a push pin, puncture holes in all four corners of the tracing, piercing the surface of the photostat below as well. Remove the tracing paper from the stat. Locate the four holes in the stat and line up the metal straightedge connecting one hole to the next. With this edge as a guide, trim the stat from one hole to the next. Lift the stat and place it on the layout. Remember this technique: using holes as a guide for trimming will come in handy very frequently.

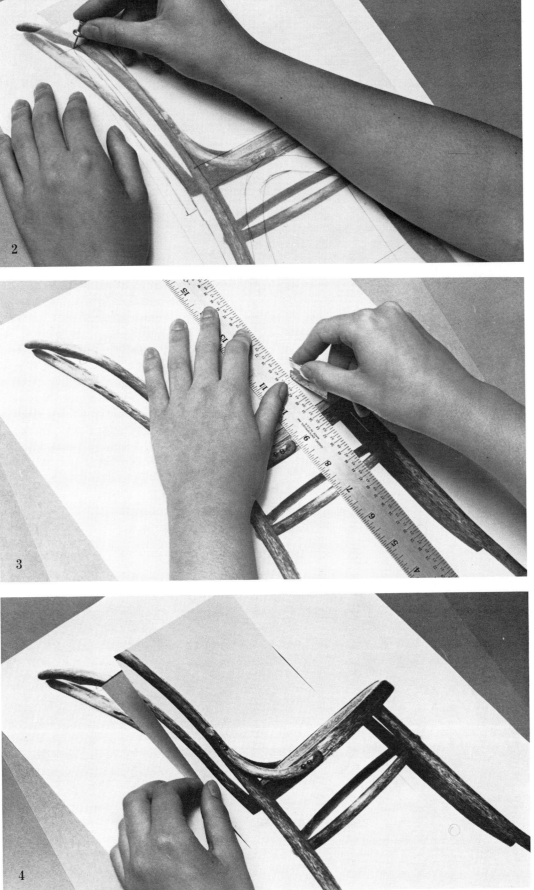

2. With a push pin, puncture the tracing at each corner, making sure to pierce the surface of the stat below.

3. On the stat line up the straightedge from one punctured corner to the next and trim along the edge.

4. By connecting the holes you will have trimmed the stat precisely to the cropping required for your layout.

REMOVING WHITE CUT MARKS

1. A negative stat will have white edges that will register as a white line in the camera unless touched up before the stat is sent to the printer. Use a black marker around the edges.

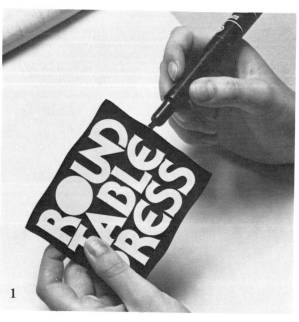

2. Touch up white cut marks on a negative stat with a black marker.

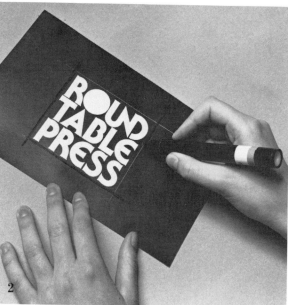

White Cut Marks on Negative Stats

You have a negative stat that you are using for line art. The white photostat paper means that there will be a white edge around the stat, which will register as a white line in the camera. Before pasting down the negative stat, paint the edges black using a marker. Touch up white cut marks on the stat in the same way.

Improvising a T-Square

You may find yourself in a predicament if you discover that you don't have a t-square available for a paste-up. But as long as you have two triangles—each with a 90° angle—you can create a substitute for a t-square. First draw a vertical line on the board and align the long vertical edge of one triangle along that line, with the hypotenuse facing out. Tape down the triangle in this position. Place the long vertical edge of the other triangle along that line, with the triangle's 90° angle at the top and perpendicular to the line and both triangles touching edge to edge. Slide the free triangle up and down the edge of the fixed triangle, and you have improvised a t-square.

IMPROVISING A T-SQUARE

Tape the long vertical edge of a 45° triangle along a vertical pencil line, with the hypotenuse facing out. Using the fixed edge as a guide, slide the long vertical edge of a second triangle up and down to create the true perpendicular needed for a substitute t-square.

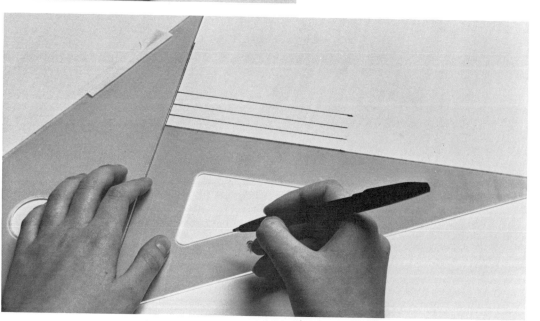

Altering Display Type

There are times when you'll want to alter display type so that it fits within a specific design scheme. Without incurring the cost of type-setting or hand lettering, you can perform this function very effectively in your studio by following some simple procedures.

Trim the display type and lay it in position. Make a tracing of the type and determine which letters or spaces between letters need to be altered in order to fit the design on the layout. Lay the display copy on a cutting surface and slice the proof where you want to make the altera-tions. Close up or extend space be-tween the letters, connect letters, or extend the letterforms simply by cutting the type and repositioning the pieces—somewhat like fitting together the pieces of a jigsaw puzzle.

To extend letterforms, slice away excess paper, space out the letters, and paste to the board, aligning them properly. Have a posi-tive (second print) photostat made that is enlarged to at least 125 per-cent of the original. On the stat fill in the white space with black ink to complete the letterforms. As you re-fine the shapes of the letters, con-necting the original form to the new sections, work carefully and use opaque white paint if necessary.

After you've done as much as you think you can, have another stat made—this time a negative (or first print)—to 125 percent. The enlarged negative will reveal the imperfec-tions in your work, giving you the opportunity to refine further with black ink and opaque white paint. After this work is complete, make a positive stat reduced to the size you need for your layout. You'll see that in reduction the type will look as clean as the original, free of any signs that you had to alter it.

1. Here three lines of type will be altered so that they will line up edge to edge.

2. The letters have been sliced with a razor blade to stretch out the let-ters in the short lines and compress the letters in the longer top line. The letters are cemented to the board and a positive stat at 125 percent is made. The spaces are filled in with black ink, the shapes re-fined, and a negative stat is made at 125 percent, on which all final refinements are made with ink and paint, and a pos-itive stat, reduced to the size required for the layout, appears to be as perfect as the original.

1

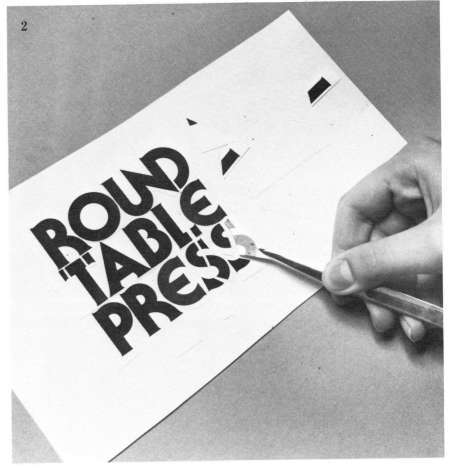

2

CURVING TYPE

1. To make a strip of type flexible enough for curving, first make vertical slices between the lower portion of the letters.

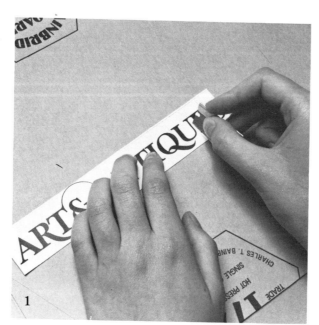

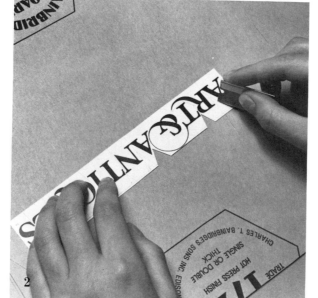

2. Turn the type upside down and notch out as much space as possible between the upper portion of the letters. Always cut away from the type, not towards it.

3. Lay the type down on the curved line and position the letters along the curve with the tweezers. The vertical cuts and the notches permit the type to bend.

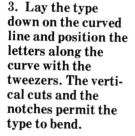

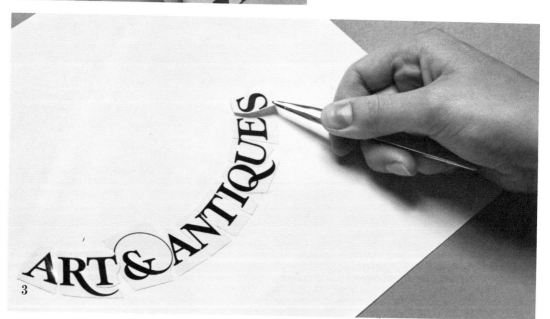

Curving Type

With phototypesetting it is possible to have type set in just about any configuration you want. But there may be times when you'll want to convert a straight line of type into a curved alignment on your pasteup.

First draw the desired curve in a light pencil line. Take the strip of type and lay it on a cutting surface. To make the strip sufficiently flexible for curving, you must make cuts between the letters. Don't slice all the way from the top to the bottom of the proof, but only part way, so that the letters are still connected to one another. To curve the type upward, slice between letters from the lower portion of the letter, always slicing away from the type, not toward it. Then turn the type upside down and remove notches of the paper from between the top of the letterforms, again slicing away from the type. Spread the type on the penciled curve, and with a tweezer, shift the letters where desired on the line. The notches permit the type to bend into any configuration.

Border Tapes

Pressure-sensitive tapes of decorative borders, are sold in rolls and in various widths and designs. To apply these borders, first draw the line to be bordered in nonreproducible blue. Pull off a length of tape longer than needed and hold it taut between your fingers. Without stretching it, place it on the guideline and rub it lightly into position with the tip of your finger. With the razor cut a 45° angle at the corner and remove the overhanging pieces. This is a *mitered* corner.

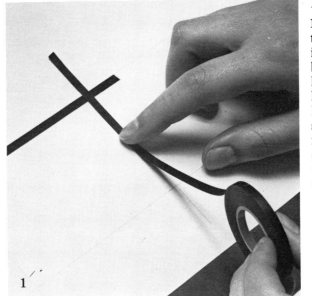

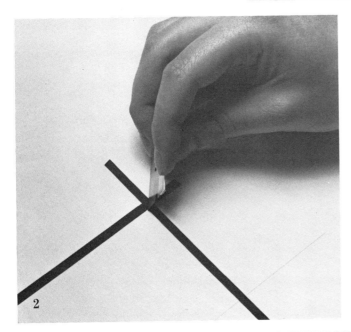

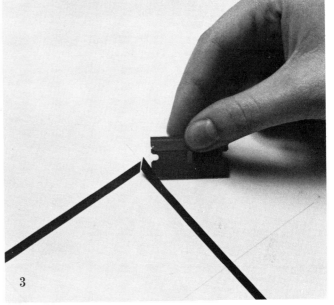

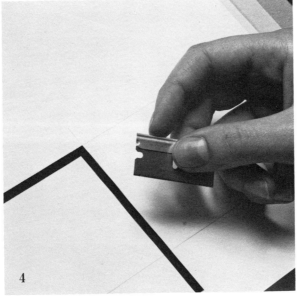

BORDER TAPES

1. To apply border tape, first draw lines in nonreproducible blue. Measure a length of tape and lay it along each line, pressing the surface with your fingers. Each strip of border tape should extend beyond the corners.

2. With the razor make a 45° slice through both layers of tape to miter the corner.

3. Remove overhanging pieces of tape.

4. The miter creates a clean corner.

MAKING A BACK-TO-BACK DUMMY

1. For a back-to-back dummy, both sides of the layout must match perfectly edge to edge and at the center fold. First create accurate layouts with trim lines and a ⅛″ bleed line on all four sides. Then take the cover layout and trim the four sides along the outer bleed line. At the center fold, slice a ⅛″ notch whose point barely touches the trim line. Make this notch at both the top and the bottom edges of the layout.

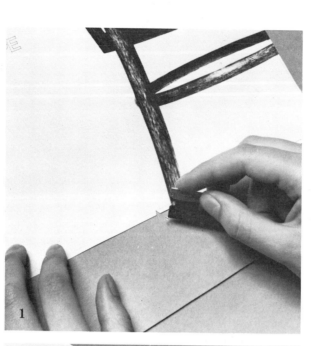

2. Make ⅛″ notches at each corner of the layout, the points barely touching the corners marked on the layout.

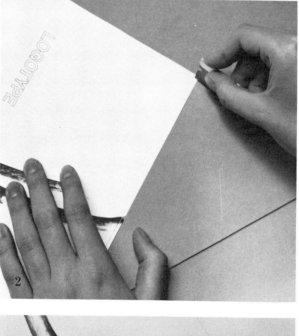

3. On the inside spread, make two notches at the center fold as you did on the cover spread.

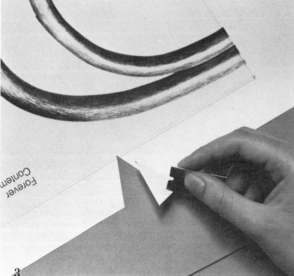

Making a Back-to-Back Dummy

When you prepare a comp for presentation, you'll want to create a dummy that closely resembles the final piece in all respects. In some cases, then, you'll need a back-to-back dummy. The trick to preparing this dummy lies in cementing the layout back to back so precisely that edges can be accurately trimmed on all four sides and the fold down the center falls in the correct position.

Create your layouts for both spreads, and in pencil, rule off the precise trim lines desired for the final piece. Add a second rule, a *bleed line*, about ⅛″ beyond the trim lines on all four sides of the layout.

Take the cover layout—the one that will appear on the outside of the dummy—and trim it on all four sides along the bleed line. Now make two notches on the center line (where the fold falls): at the top edge and at the bottom edge of the layout. Each notch should be ⅛″, and it should cut through the bleed line, its point barely touching the trim line. Notch the four corners in the same way, ⅛″ into the bleed line, the points barely touching the corners marked on the layout.

Now take the inside spread and cut out notches at the top and bottom of the fold line in the center and at the four corners, as you did on the first spread. Using the slipsheet method, mount one stat on the other back to back. Line up the notches at the four corners and at the center, and remove the slipsheet while the stats are so positioned.

With the edge of the plastic triangle, connect the center notches, and using a jumbo paper clip, score along the edge of the triangle to create the fold in the center. (A large paper clip is ideal for this purpose because it will not damage the surface of the paper as you score it.) Trim all four sides of the piece along the trim lines.

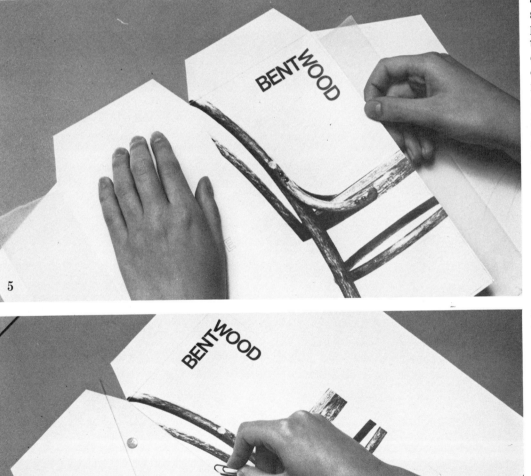

4. Notch the four corners as well. Cement the backs of both layouts and allow the cement to dry.

5. With the inside spread face down, place a tissue over the back. Place the cover spread face up over the tissue and match up the notches at the corners and the center. Remove the slip-sheet, mounting the two stats in position.

6. Using a plastic triangle as a guide, connect the two center notches and score along this edge with a large paper clip.

7. Trim the layouts on all four sides along the trim lines and score the center fold on the outside of the dummy with a razor.

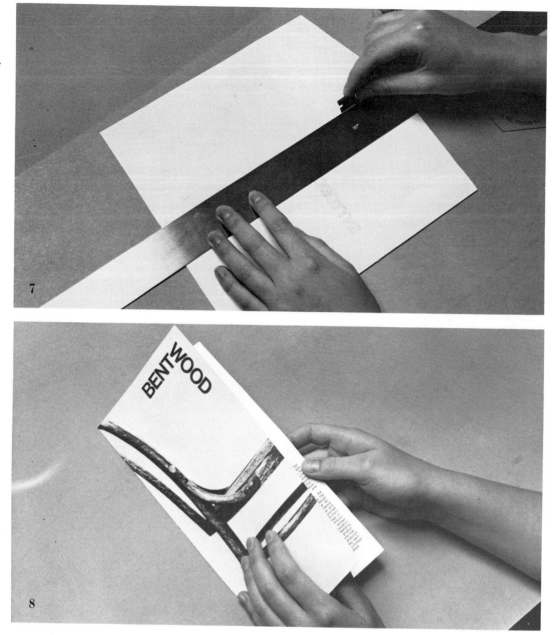

8. A back-to-back dummy simulates the finished piece almost precisely.

Quick Register Marks

There may be times when you'll need to create your own register marks. It is much easier to match up circles drawn with a compass than it is to match up overlapping lines or crosses.

With the acetate overlay in place, set the compass for a circle about ½″ in diameter and draw a circle on one margin of the acetate in ink. Make another circle on the opposite margin. Be sure to pierce through the acetate and into the board below. Set the compass aside, but do not change the adjustment, because you must make another set of circles the same size. After the ink has dried thoroughly, lift the acetate and insert the needle of the compass into the existing hole and draw a cirlce. Create another circle using the same method on the other side of the board. Now the overlay is registered.

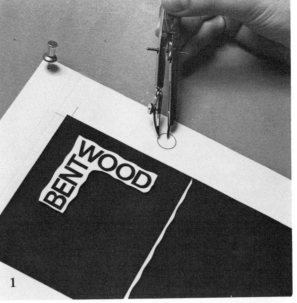

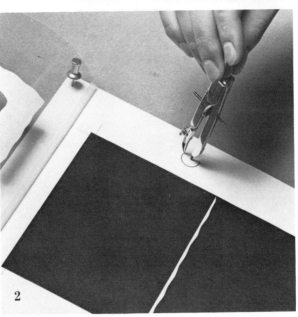

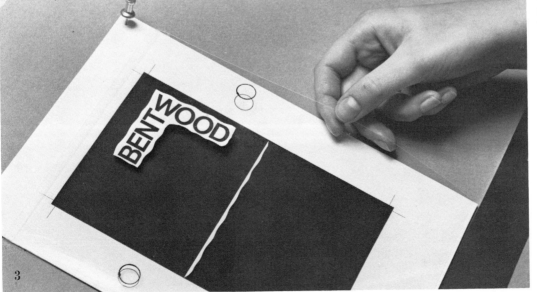

1. First position acetate over pasteup. Draw two circles on the acetate, each on opposite sides, puncturing the acetate *and* the board with the needle of the compass.

2. After the ink has dried thoroughly, carefully fold back the acetate, and place the needle of the compass into the hole in the board, punctured when you made the first circle.

3. Make the circle on the board to obtain a perfect register between overlay and pasteup.

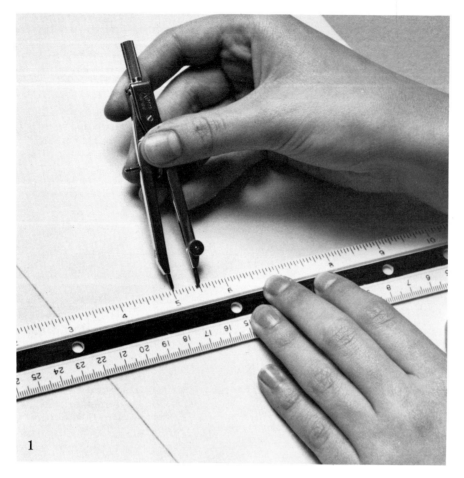

Parallel Lines with a Compass

There will be times when you'll be required to draw several equally spaced parallel lines. You may be tempted to mark off these spaces by measuring down the page with a ruler, but this can be time-consuming, and there are many opportunities for error.

Using a compass is a far easier way to create equally spaced parallel lines. First determine the amount of space you want between each line. Set the compass on a rule, and open the instrument to the desired dimension. Moving to the paper now, rule off the margins of the page and draw the top line with the t-square as a guide. Place the needle of the compass at the edge of this top line and lower the pencil to the next line, using the compass as you would a pair of dividers. Move the t-square up to this point, draw the second line, and do the same with each line in succession.

PARALLEL LINES WITH A COMPASS

1. Use a compass to draw a series of parallel lines. Set the compass to the amount of space desired between the lines.

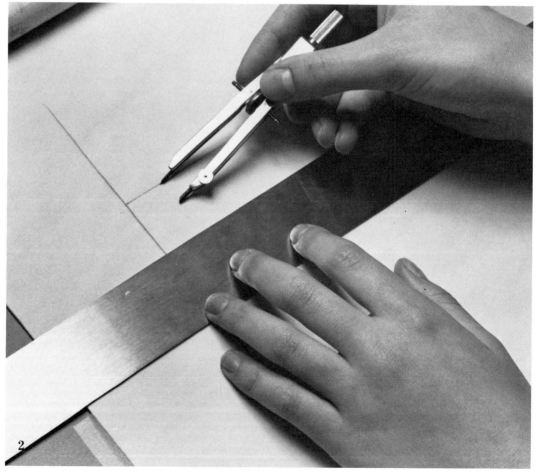

2. After marking off margins, draw the first line at the top with the t-square as a guide.

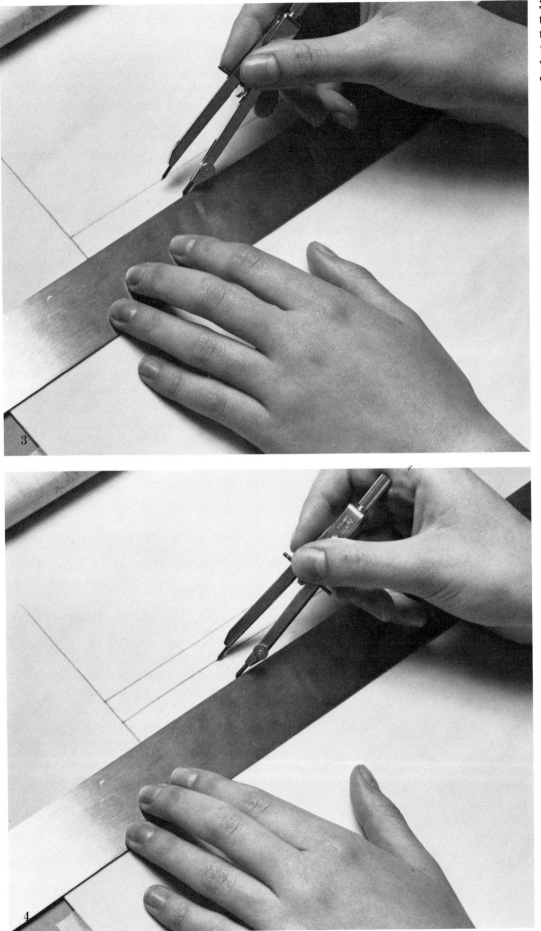

3. Set the t-square to the next point, using the compass as you would a pair of dividers. Draw a second rule.

4. With the compass and the t-square as guides, draw the next rule. Continue in this manner down the page.

Handy Spacing Gauge

Respacing lines to fit within a specific depth can be extraordinarily tedious. Yet not so with this homemade spacing gauge, designed to make this job almost effortless. With this gauge, you can reduce or add leading, establishing with ease precisely where each line should be placed. Trace the gauge shown here or follow these instructions for creating one of your own.

Draw a vertical rule and mark it off into 30 equal spaces of 1 pica each. At the center point of this rule (15 picas), draw a perpendicular rule to the left, making it as long as you choose to point *A*. Now draw rules from each of the 30 points to point *A*, so that each rule seems to originate from the same point. To the right of the vertical rule, continue the 30 points to any convenient length, but one that measures at least the depth of your type page, but not greater than 12″. Now draw several parallel vertical rules at intervals between the two extremes. These are simply visual guides to help you with alignment later. They are not units of measurement. It's also convenient to number three or four columns from 1 to 30.

The spacing gauge, drawn in this way, should be made on a transparent surface. Draw these rules on acetate. If you have a stat house that provides stats on acetate, you can make the drawing on white bond and have the house print it on a transparent sheet for you. You'll find this gauge will be useful on many occasions.

For respacing a column of type, cement the proof with one-coat and let it dry. Make your cuts between the lines as described in the previous chapter.

In our example, we will respace a column from a 31-pica depth to a depth of 37 picas. Lay the spacing gauge over the copy and shift the gauge from left to right until the bottom of the first character in each line sits on a rule on the gauge. The first and last line of the copy will touch the first and last rule of the gauge. This shows you where 31 picas falls on the spacing gauge.

Now shift the spacing gauge to the right to see where 37 picas will fall if the first character in the first line sits on the top rule of the spacing gauge. Holding the gauge at this point, hinge it at the top of the board. Using the spacing gauge, draw in a light pencil a guideline for the 37-pica depth on the board. Lay the last line of copy onto this penciled guideline.

Now the spacing gauge will help you establish the spacing for each remaining line of copy at the new pica depth. Lower the gauge and position the next line of copy, using your tweezers, so that the first character in that line touches the next rule on the gauge. Continue to lift and lower the gauge as you pull away each new piece of copy and follow the rules on the gauge as a guide for their placement.

This example shows how to *add* space between lines. If you want to *reduce* space, slide the gauge to the left, rather than to the right, and follow the same procedure.

HANDY SPACE GAUGE

1. This is the pattern for a spacing gauge that is designed to help you add or reduce space between lines. The gauge is ruled on acetate.

1

A

2. In this example, a column of type will be respaced from a 31-pica depth to a depth of 37 picas. First make horizontal cuts between each line of copy.

3. Lay the spacing gauge over the copy and shift it until the base of the first character in each line touches a rule in the gauge.

4. Now shift the gauge to the right and hinge it to the board so that the first character on the line touches the top rule and the bottom rule on the gauge is at the 37-pica depth.

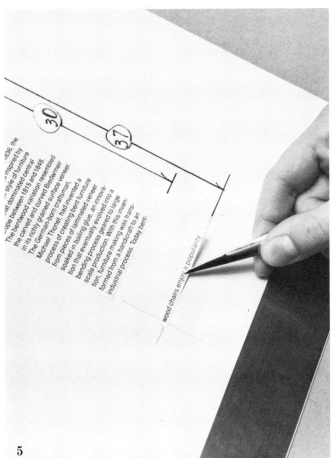

5. Lift back the gauge, lightly mark the 37-pica depth on the board with a pencil rule, and place the last line of copy on that guideline.

6. Lower the spacing gauge and place the next line of copy at the point where the first character touches the next rule on the gauge.

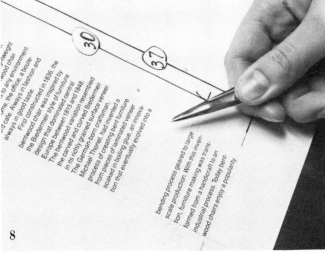

7. Continue to place each line of copy so that the first character touches the next rule on the gauge.

8. Respace the entire block of copy this way. No calculations are necessary with this method, and the results are bound to be accurate.

1. To divide the width of this rectangle into five equal parts, extend one vertical side. Working off the opposite corner, pivot a ruler until it touches this extended line at a point that is a multiple of 5. Here we have used 10″.

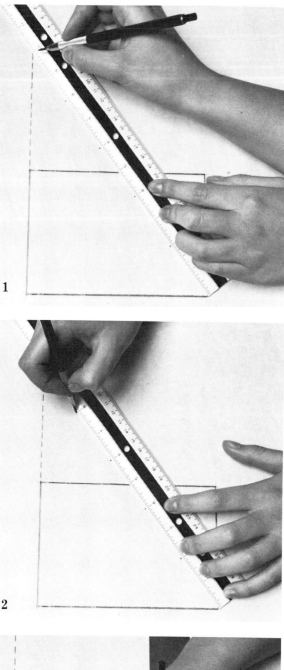

2. Tick off intervals at every 2″ along this diagonal.

3. From these points, draw lines parallel to the side of the rectangle.

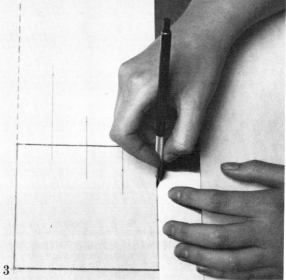

Dividing a Space into Equal Parts

There are many occasions when you'll find it necessary to divide a line or a space into equal parts, particularly if you do any work requiring charts and graphs. Accomplishing this feat is made possible through some simple geometric procedures.

Let's take a rectangle and divide the *width* into five equal sections. (The procedures shown here are the same as those used for dividing a line into equal spaces.) Extend one side of the rectangle to any desired length. Line a ruler up at the opposite corner, and pivot it until it touches this extended side at a simple multiple of 5, say, at 10″. Holding the ruler at this point, tick off pencil marks every 2″. With a t-square draw vertical lines at the tick marks parallel to the extended line. They represent five equal vertical sections.

Now let's divide the *depth* of this rectangle into three equal sections, creating equal small rectangles within the larger rectangle. Working off the same corner as you did earlier, pivot the ruler to arrive at a multiple of 3. It happens here that the 6″ mark falls on the horizontal side of the rectangle. (We could have marked off 9″ from the extended line as well, of course.) After ticking off points at every 2″ interval, rule parallel horizontal lines to make three equal sections.

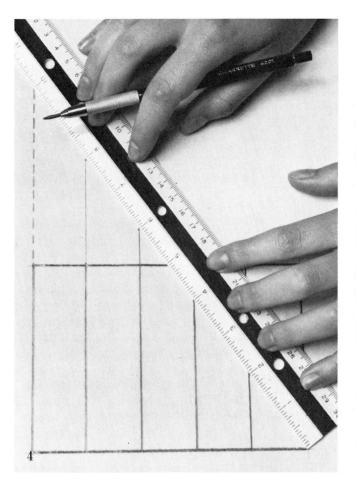

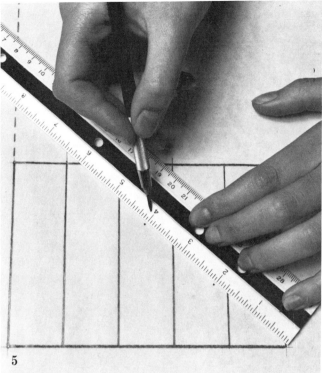

4

5

6

4. By drawing these lines from one side of the rectangle to the other, you have divided the width into five equal sections.

5. To divide the height of the rectangle into three equal sections, follow a similar procedure. Working from the same corner, pivot the ruler so that it touches a point on the top rule at a multiple of 3. Here the ruler touches the top line of the rectangle at 6″. Tick off intervals every 2″.

6. Draw lines parallel to the sides from these points, and the height of the rectangle is divided into equal spaces. The same principles apply to dividing a line into equal parts.

1. **Here is an odd shape that needs to be enlarged. To see how much it must be enlarged to fit the desired layout, you must scale it. The object here is to enclose the shape within a square or rectangle so that it can be computed mathematically as you would in scaling any regular shape.**

2. **After enclosing the shape within a rectangle, determine the new height and mark it at *B*. Extend a vertical line through point *B* and a horizontal line from *B* well beyond the anticipated point *C*. Now mark a line from point *A* through the corner of the small rectangle to intersect the**

Scaling Irregular Shapes

It often happens that the studio artist is required to scale art that comes in very irregular shapes. Planning ahead is important here, because you'll probably need to know precisely how scaling will affect the layout—if you enlarge the height to 5″, where will each section of the width fall on the layout? Establishing these points will help prevent an unexpected outcome.

The object in scaling an irregular shape is to enclose the extremes of the shape within a square or rectangle in order to compute the enlargement or reduction mathematically.

First extend the left side of the art to its highest point. Then extend this line further to the height you desire for your layout. Now enclose the image within a rectangle, marking off horizontal lines at the base and the top of the art and finally along the sides. Using the diagonal scaling method, enlarge the overall size as you would a square or rectangle.

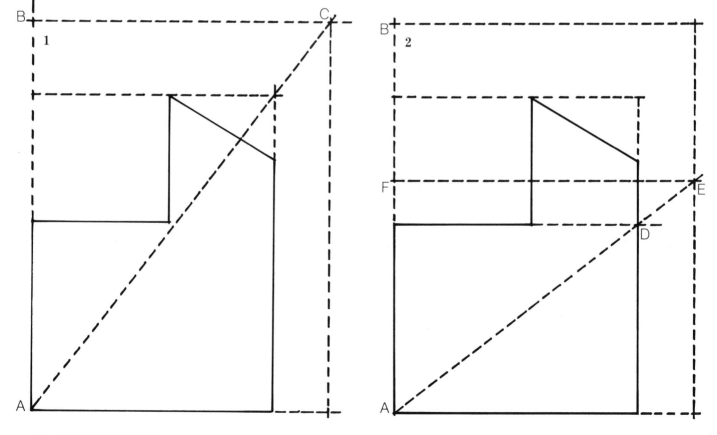

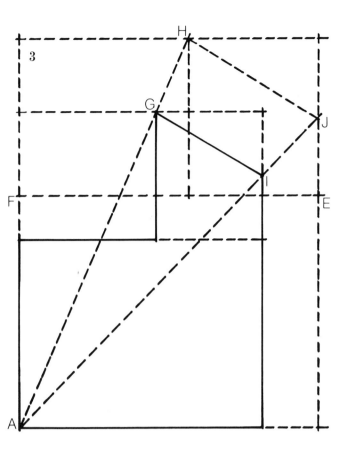

line from point *B*, creating an intersection at *C* to establish the new width. Now mark a vertical line from point *C* to intersect the baseline. You now have the new *overall* size, but how can you determine precisely where the contour *within* the shape will fall on the layout?

3. Extend the solid horizontal line at the top of the shape to intersect a solid vertical line at *D*. Now extend a line from *A* through *D* to intersect the new width line. This becomes *E*. Draw a horizontal line from *E* to line *AB*, creating the intersection *F*.

4. To locate the position of the angle, draw two diagonal lines from *A*—one through *G* to *H* and one from *A* through *I* to *J*. When you've joined points *H* and *J*, you've established the angle of the slope, as well as the location of the acute angle. Now draw a vertical line from *H* to intersect line *EF*. It is now possible to determine where every element in the shape will fall in the new layout.

5. All the diagonals, verticals, and horizontals connected by solid rules show the proportionately enlarged shape.

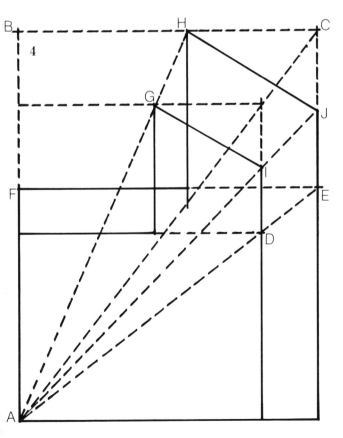

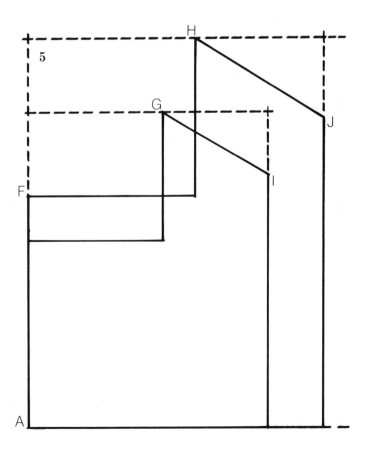

GLOSSARY

A.A.: "Author's alteration," an abbreviation used to identify a change in typeset copy that is not an error made by the compositor.

Acetate: Transparent plastic sheet available in a number of trade names, such as Mylar or Cronar. Used primarily for copy overlays.

Acetate proof: Proof provided by typesetter or printer that is prepared on an acetate sheet, a desirable material for visualizing layouts.

Agate: Unit of measurement used in newspapers; 14 agate lines equal 1 inch.

Airbrush: An instrument used primarily for retouching continuous tone art. Small droplets of paint or dyes are sprayed through a gun to create tones on halftone art.

Alignment: Arrangement of type and/or art so that each is in line vertically and/or horizontally with the other.

Art: Illustrative material to be reproduced. Also known as *artwork*.

Ascender: The portion of the lowercase letterform rising above the main body of the letter, in such letters as *b, f, h, k*.

Baseline: The imaginary horizontal line on which the base of letters or characters rests.

Benday: Screened percentages of tones printed on pressure-sensitive plastic sheets with a release paper backing. See also Shading sheets.

Bleed: Printing beyond the edge of a sheet's trim marks so that the printed image extends to the edge of the trimmed sheet. In preparing art for reproduction, the studio allows an additional ⅛″ beyond the trim lines for a bleed.

Blockout film: See Masking film.

Blueprint: A photocopy of a negative prepared by the printer as a proof. The chemical process used renders the image in a blue tone.

Borders: Decorative lines or designs that are drawn, applied as dry transfer, or set in type.

Bourges: Trade name for a thin, two-layer, color-coated acetate overlay sheet keyed to standard printing inks. To use, place pressure-sensitive film on layout and trim as desired.

Brown print: A photocopy of a negative prepared by the printer as a proof. The chemical process reproduces the image in a brown tone. Also called a Van Dyke.

Burnish: To rub over the surface with a hard, smooth instrument to adhere copy to another surface.

Camera ready: Type or art that has been completely prepared with carefully marked instructions for the printer. A mechanical is camera ready.

Casting off: After characters have been counted in a manuscript, the count is converted into a calculation that determines the amount of space to be occupied in type.

Character count: The amount of characters contained in a body of text.

Characters: Individual letters, numbers, punctuation marks, etc., that appear in copy.

Chrome: Color transparency. A positive photographic image on transparent film.

Color-matching system: A system of matching a color to a specific printing ink formula. Numbers are assigned to colors and keyed to color swatches and ink formulas in order for the printer to match the color in final reproduction. PMS is the most widely used color matching system.

Color proof: Prepared by the printer, a color proof indicates the way in which process color will register and print so that the client can make adjustments prior to printing.

Color separation: When color art is photographed at the printer, filters are used to separate out individual colors, which, when combined in printing, will give the illusion of a full-color image.

Color transparency: Chrome. Positive photographic image on transparent film.

Composing room: The place in which type is set.

Compositor: Typesetter.

Comprehensives (comps): Finished layouts that provide a precise indication of how the final reproduced piece is intended to appear.

Continuous tone art: Art with values of tones ranging from black to white. As opposed to line art. See also Halftone.

Copy: Any material used for typesetting or printing.

Copyfitting: The process of counting characters and casting off to determine the amount of space required for any given copy.

Copy overlay: An acetate overlay on which is cemented or drawn camera-ready copy.

C-print: A color print made from a film negative, generally prepared to size for layout purposes.

Crop marks: The short rules marked on borders or overlays to indicate where the art should be cropped.

Cropping: The selection and indication of an area of art to be used for reproduction.

Cyan: The blue used in color separation. Also called *process blue*.

Descender: The portion of the lowercase letterform extending below the main body of the letter, in such letters as *g, p, y*.

Diagonal line scaling: A method of determining the correct proportions of the art when it is enlarged or reduced. Obtained by drawing a diagonal line through two opposite corners of the rectangle and extending the base and top lines of the rectangle until they meet the diagonal.

Display type: Type that is larger than text type, generally 14 points or larger. Also called *headline type*.

Dots: The result of screening a continuous tone or a flat tone image.

DP (direct positive): A type of photostat obtained without an intermediate paper negative.

Dropout halftone: A halftone in which the dots in the highlight areas have been eliminated.

Dry mount: The process of adhering two surfaces after the initial application of cement (generally two-coat rubber cement) has dried.

Dry transfer type: A complete alphabet mounted on a plastic sheet. Letters are generally transferred to another surface by means of burnishing. Several manufacturers produce a variety of faces and sizes.

Dummy: A layout for the designer and/or client showing where the elements in a design will be placed.

Duotone: A two-color halftone made from a black and white photograph.

Editing: Reading copy for fact, spelling, grammar, punctuation, style consistency, and organization prior to typesetting.

Elite: A typewriter with 12 characters per inch.

Engraver: The place where printing plates and dyes are made.

First print: The reverse—or negative—of the art provided to a photostat house.

Flat art: Line art.

Flat tone: An area of dot formation creating a single tone value without gradation. The dots are equal in size and equally spaced. Also called a *tint* or *screen tint*.

Flop: Turning over a negative before printing to create a mirror image.

Four-color process: Method of reproducing by separating the color image into red (magenta), yellow, blue (cyan), and black to create four printing plates, which—when combined—produce the full-color original.

Galley proof (galleys): Rough proofs provided by the typesetter for proofreading and layout purposes.

Glasene (glasene proof): A proof provided by the typesetter that is printed on a transparent sheet of paper or acetate so that the studio artist may place it over the layout for checking purposes.

Glossy: A photograph printed on glossy—rather than matte—paper.

Goldenrod paper: A masking paper, gold in color, used in stripping to position negatives in correct alignment for platemaking.

Greek type: A method of indicating type in which the shapes of the letters are imitated without creating actual words.

Haberule: A gauge used for determining the depth occupied by various sizes of type and leading.

Hairline register: The precise registration required when two images butt.

Halftone: A continuous tone image that in order to reproduce is photographed through a screen so that the tones are translated into a series of extremely tiny dots for printing. The screen breaks up the tones into dots, densely or sparsely placed depending on the quality desired that—when seen from a normal viewing distance—give the illusion of a continuous tone.

Headline type: See Display type.

Highlight: The lightest area in continuous tone art.

Highlight halftone: See Dropout halftone.

Holding lines: Rules drawn in black or red to outline the area and placement of the art to be reproduced on a page.

Justified type: Lines of type that align on both left and right.

Keyline: A mechanical in which all elements are prepared on a single pasteup board with no copy overlays. All instructions are marked on and the printer performs all shooting and stripping operations from the single board.

Layout: Preliminary drawings made by the designer to indicate the proposed plan for the final design. Layouts may range from small quick thumbnails, to roughs, to comprehensives, each made with increasing attention to detail and accuracy of presentation as a guide for the studio, client, and/or printer.

Leading: Space inserted between lines of typeset material.

Letterspacing: Space inserted between characters.

Line art: Art that is either black or white, with no gradations in between.

Line conversion: The conversion of continuous tone art into line art for line reproduction.

Linespacing: Space inserted between lines.

Lowercase: The small letters—as opposed to capitals—in an alphabet.

Magenta: The red used in color separation. Also called *process red*.

Masking: Blocking out a portion of an illustration to prevent it from being reproduced.

Masking film: A transparent red or amber film on a plastic sheet. The film is peeled away from the backing sheet and then placed on the art or mechanical to block out the area as a guide to the printer. Although the film itself is transparent, it registers as a solid black by the printer's camera.

Measure: Length of a line of type.

Mechanical: The type and art prepared as camera-ready copy for the printer. All elements are cemented in accurate position on a board and any overlays are prepared so that the printer can photograph and strip the elements precisely as specified.

Moiré: Unpredictable pattern created by incorrectly overprinting two or more screened areas.

Mortise: A space created by cutting away unwanted characters from a reproduction proof when corrections are desired. New type is inserted into this space. See also Railroading.

Outline halftone: See Silhouette halftone.

Overlay: A transparent or translucent sheet placed over art or mechanical. A tissue overlay is used for simple instructions to the printer while a copy overlay—generally on an acetate sheet—carries camera-ready copy to be photographed by the printer.

Overprinting: Printing on an area that has already been printed. Also called *surprinting*.

Pasteup: Camera-ready copy with all elements in position on a board. Often used as a synonym for "mechanical," although the pasteup may actually be only one portion of the entire mechanical.

P.E.: "Printer's error," an abbreviation used to identify a correction in typeset copy that is the result of an error made by the typesetter.

Photostat: Referred to as a "stat," this is an inexpensive photoprint made by a camera capable of generating images with or without a paper negative. Stats are used by the studio to indicate size and position of original art in the layout or sometimes for line art as original art. Stats may be reversed or flopped, matte or glossy, depending on the specific requirements of the studio.

Pica: Typographic unit of measurement; 12 points equal 1 pica and 6 picas equal 1 inch. Also a typewriter with 10 characters per inch.

PMS (Pantone Matching System): The most widely used color-matching system.

PMT (Photomechanical Transfer): A trade name for a type of photostat obtained without the use of an intermediate paper negative.

Point: Smallest typographical unit of measurement; 12 points equal 1 pica and 1 point equals approximately 1/72 of an inch.

Preseparated color: A method of preparing color art for the printer by which the studio separates the colors with acetate overlays, so that each can be photographed individually by the printer. This is opposed to process color, by which the printer separates the colors with filters from a single full-color image.

Process camera: The special camera used by the printer to photograph art for reproduction. Process work includes halftones, color separation, etc.

Proofs: Typeset copy sent by the compositor to the client for checking and making corrections.

Proportional scale: A device used to determine the size of the art when it is enlarged or reduced for reproduction.

Railroading: A technique used in making copy corrections. The unwanted copy is removed from the original by slicing above, below, and alongside the characters and lifting them away. The mortise that results

provides a space into which the new, trimmed copy is inserted and shifted into correct position.

Register: Overlapping two or more images in precise relationship to each other.

Register marks: Marks—generally crosses or circles—placed on pasteups and overlays so that two or more images may be positioned accurately for perfect alignment.

Reproduction proof: A quality proof of typeset material that is camera ready and can be used as copy in preparing a mechanical for reproduction. Also called *repro*.

Retouching: A process of correcting or improving art, especially photographs, before negatives are made. Done with paints or dyes applied with brush or airbrush.

Reverse: To change black and white relationships, negative to positive, and vice versa. Generally refers to line art.

Rough: A casual layout used to indicate the overall plan for a design.

Rubylith: A trade name for a red masking film.

Rule: A line obtained with a straightedge and ruling pen.

Same size: Instruction to the printer or photostat house to reproduce art the same size as the original. Written as "s/s" or "s.s."

Scaling: Calculating the proportions of art for enlargement or reduction to fit a particular area.

Scaling wheel: A device used to determine the proportional size of the art when it is enlarged or reduced for reproduction.

Screen: A finely cross-ruled sheet of glass that is placed in a process camera. Art is photographed with this in order to translate tones into dots for the reproduction process.

Screen tint: An area of dot formation creating a tone value without gradations. The dots are all equal in size and equally spaced. Also called a *tint* or *flat tone*.

Second print: A positive. A photostat house uses the term to designate a print that has the same relationship of black to white as that in the original art. The first print is the negative, the second is the positive.

Shading sheets: Patterns of lines or dots on pressure-sensitive sheets that can be burnished onto line art to create tonal values. Also called *shading film* or *tint sheets*.

Silhouette halftone: A halftone of a specific area. The background is removed in order to show the contour of the art.

Silhouetting: The process of outlining original art so that the desired contour is achieved.

Solid: Type set with no spacing (or leading) between the lines.

Spec book: A catalog containing specimens of all the typefaces, in all sizes and variations, available from a specific typesetter.

Square halftone: A halftone that forms a rectangle or square. To differentiate it from a silhouette or other type of halftone.

S/S: See Same size.

Stripping: The process of assembling several negatives—of art, type, etc.—into a single negative on a paper or film base so that each element is placed precisely as it will be reproduced on the page.

Surprinting: Printing over an area that has already been printed. Also called *overprinting*.

Text type: Main body type, usually 12 point and smaller.

Thumbnails: Small, casual sketches used as a rough indication of a design plan.

Tint: An area of dot formation that has a tone value without gradations. The dot are all equal in size and equally spaced. Also called a *screen tone* or *flat tone*.

Tissue overlay: An overlay, generally of visualizer paper, on which simple instructions are written to the printer.

Transfer type: See Dry transfer lettering.

Trim lines: The rules made on a mechanical to indicate where the page will be trimmed after reproduction.

Trim size: Final size of a printed piece after trimming.

Type gauge: The instrument used to calculate type size and leading to fit copy within a given space.

Uppercase: Capital letters in an alphabet.

Van Dyke: A photocopy of a negative prepared by the printer as a proof. The chemical process employed renders the image in a brown tone. Also called a *brown print*.

Velox: A photographic halftone paper print made from continuous tone art for use as line art.

Window: Made with masking film, an area shaped and positioned to indicate to the printer the desired size and placement of the art in the layout.

X-height: The height of the main portion of a lowercase letter, not including ascender or descender.

SELECTED BIBLIOGRAPHY

Bookmaking
By Marshall Lee
R.R. Bowker Company, New York, 1979

Designing with Type
By James Craig
Edited by Susan E. Meyer
Watson-Guptill Publications, New York, 1980

Graphic Arts Manual
Arno Press
Musarts Publishing Corp., New York, 1980

Graphic Master
By Dean Phillip Lem
Dean Phillip Lem, Los Angeles, 1974

Lettering for Reproduction
By David Gates
Watson-Guptill Publications, New York, 1969

Pocket Pal
International Paper Company, New York

Production for the Graphic Designer
By James Craig
Watson-Guptill Publications, New York, 1974

Metric Conversions

Metric conversions for measurements commonly referred to in inches in this book are listed below:

⅛″	.3175 cm	5″	12.70 cm	9″	22.86 cm
¼″	.635 cm	5⅞″	14.92 cm	10″	25.40 cm
½″	1.27 cm	6″	15.24 cm	11″	27.94 cm
¾″	1.905 cm	6½″	16.51 cm	12″	30.48 cm
1″	2.54 cm	7″	17.78 cm	20″	50.80 cm
2″	5.08 cm	8″	20.32 cm	24″	60.96 cm
3″	7.62 cm	8¼″	20.96 cm	31″	78.74 cm
4″	10.16 cm	8½″	21.59 cm	42″	106.68 cm

INDEX

Italics indicates illustration.